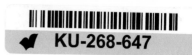
KU-268-647

CONTENTS

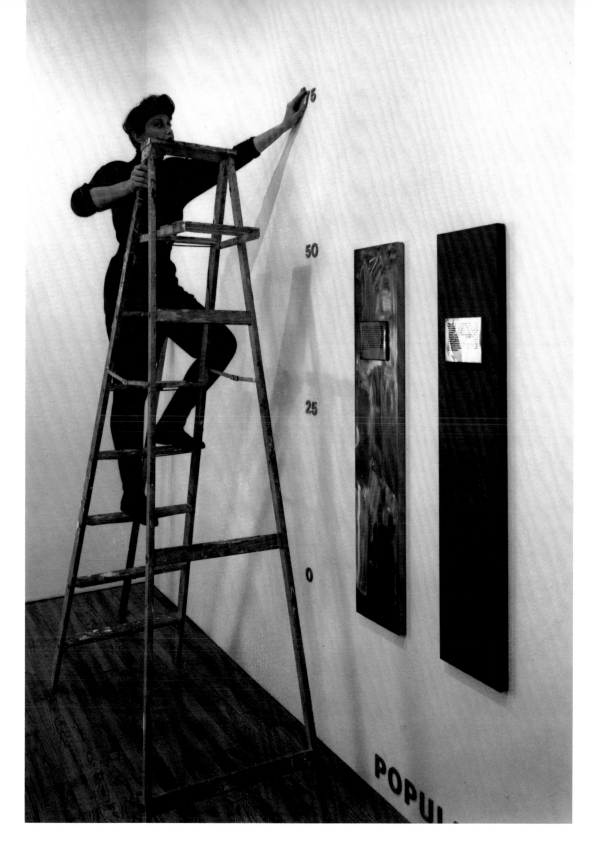

Mary Kelly working on *Potestas*, 1989.

When Mary Kelly and the late William Olander, Senior Curator at The New Museum, first met at the Museum's *Difference: On Representation and Sexuality* exhibition in 1984, she had just begun *Corpus*, the first of a four-part project to be titled INTERIM. Completed in 1985, *Corpus* was exhibited extensively in Europe, where the American-born artist was living and working at the time. Bill felt that it would be important to show *Corpus* in the United States, where Mary Kelly's art and writings had been instrumental in shaping the understanding of sexuality and representation of a generation of artists and critics. As the discussion developed, though, the ideas for the current exhibition began to take form. It was decided that Mary would complete INTERIM's remaining sections in close collaboration with The New Museum, where the first exhibition of the completed project would be presented.

The exhibition, the catalogue, and the symposium have been produced with the assistance of many individuals. On behalf of The New Museum, I wish to extend my appreciation to Norman Bryson, Griselda Pollock, and Marcia Tucker, who have written imaginative and wide-ranging essays for the catalogue, and to Hal Foster for his incisive interview with Mary Kelly. I also thank Deirdre Summerbell for undertaking the complicated task of editing the entire catalogue, which she has done with astuteness, care, and perception, and under considerable time constraints; and for their excellent catalogue design, Jill Korostoff and Susan Sellers of Emsworth Design. Magdalena Sawon, the director of Postmasters Gallery in New York, has also been extremely helpful in the research, documentation, and presentation of this exhibition. I would also like to thank Ray Barrie for his invaluable support throughout the production of the work for this exhibition.

We are pleased that INTERIM will also be exhibited at the Vancouver Art Gallery, Canada, and The Power Plant, in Toronto, and we thank Gary Dufour, Senior Curator in Vancouver, and Louise Dompierre, Chief Curator at The Power Plant, for their enthusiasm and support. We are also grateful to the Vancouver Art Gallery for lending their recent acquisition, *Pecunia*, for exhibition and tour.

The New Museum is grateful for the contribution toward the funding of this exhibition from the New York State Council on the Arts.

I would like to express my appreciation to the staff of The New Museum for their efforts and support in presenting this exhibition. I greatly appreciate the contributions of other New Museum curators to the development of the project, in particular, Laura Trippi and Milena Kalinovska, while she was Adjunct Curator. The symposium on INTERIM has been organized by Susan Cahan, Curator of Education; my thanks for her considered approach to developing public programs and education for the exhibition. I also wish to note in particular the patient and untiring work of Alice Yang, The New Museum's Curatorial Coordinator, and the unique contributions of Toni DeVito, Sara Palmer, Debra Priestly, and Virginia Bowen towards the project's funding, publicity, and installation, respectively. Special thanks must also go to Lisa Zywicki and Carol LeBras from the curatorial department for their assistance in preparing the catalogue manuscripts, and to Luis De Jesus for his help in researching the bibliography.

Finally, The New Museum is indebted to William Olander for initiating the dialogue which led to this exhibition, and we especially extend our deep gratitude to Mary Kelly, who has generously and patiently participated in all aspects of its development and realization. We believe the exhibition and catalogue constitute a significant representation of her work. The exhibition's title, INTERIM, expresses the open-ended nature of Kelly's project, and captures the moment and position of exchange in the artist's reflection on, and production of, her work. It reminds us not only of the transitional and transitory nature of our speech, our commitments, our positions, and our experience, but also of the necessity of our struggle to identify and maintain the things which we discover to be important through communication. With INTERIM, Mary Kelly has completed a major work of art and contributed a body of ideas to art history and theory which are, at one and the same time, eloquent and profound.

GARY SANGSTER
Curator

he's changed. Lovely dancer's body i
e leather jacket, lace-up boots, all a
er face, small features more defin
mblazoned: live alone, a loft down
nse baby, if you want to be an ar
n in debt, no doubt about it, overdr
tted, wishing I could seek asylum
nned by the 'rightness' of that image
by every detail, but especially b
d a presence much like hers, older i
ctive without trying too hard. They
o have them, kept on looking for me
und some that were similar, not so
tylishly distressed at least. In these
ore them all the time, have them o
he be wearing hers? The door. I let
e boots are different, lighter, highe

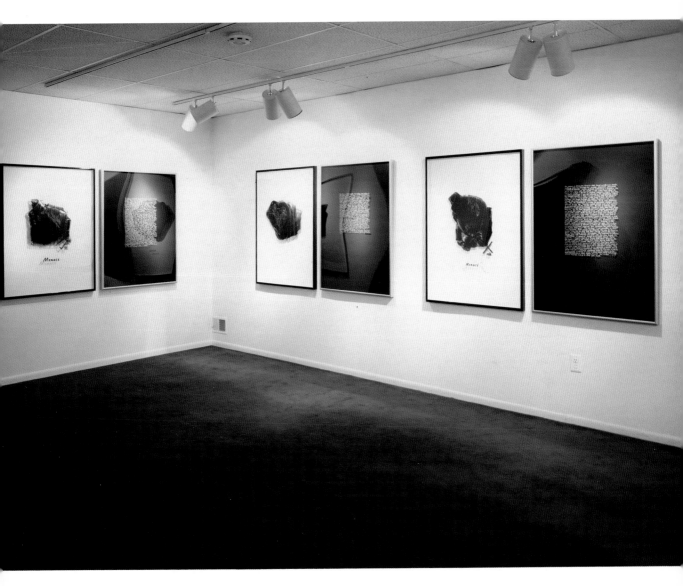

PART I | **CORPUS** 1984–85, 30 panels, 36 × 48″ each, laminated photo positive, silkscreen, and acrylic on plexiglass. Left: detail from "Supplication" section. Right: installation view at McNeil Gallery, Philadelphia.

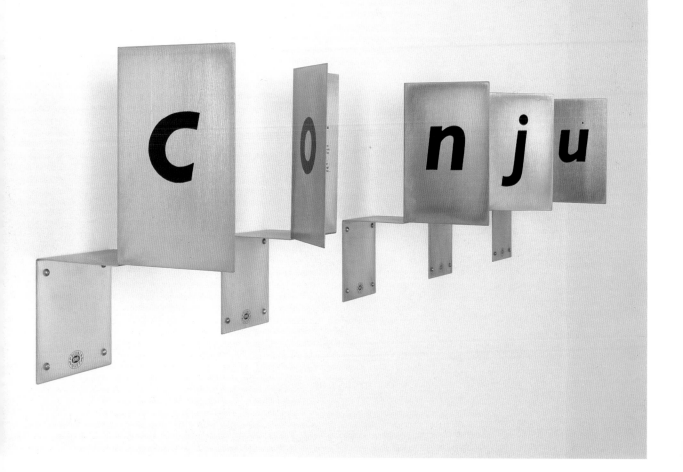

PART II | **PECUNIA** 1989, 20 units, 16 × 6½ × 11½″ each, silkscreen on galvanized steel. Collection Vancouver Art Gallery. Left: "Conju" section. Right: detail from "Conju" section.

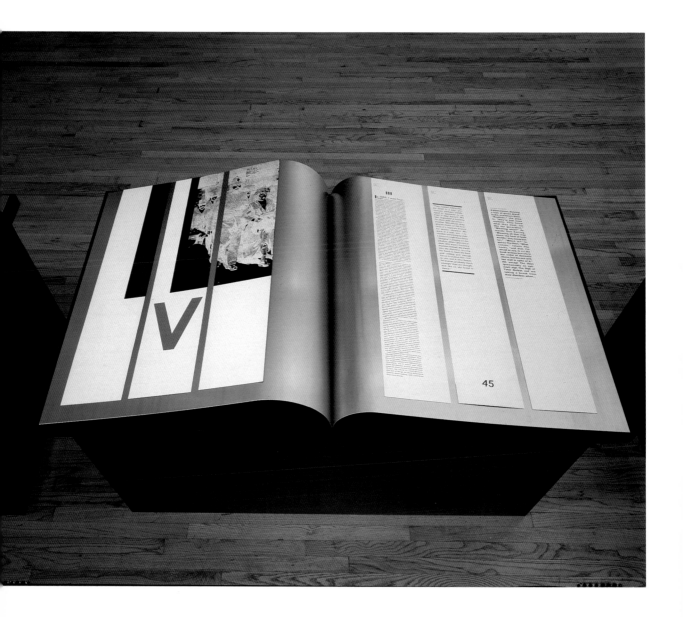

45

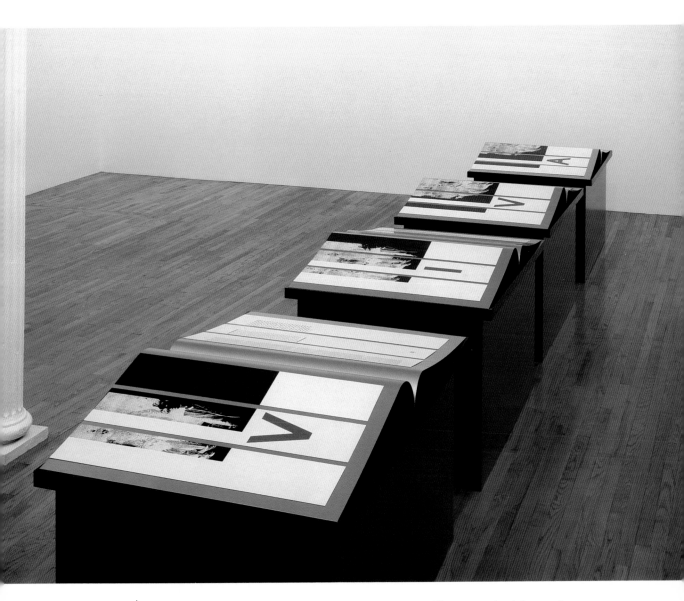

PART III | **HISTORIA** 1989, 4 units, 61×36×29″ each, oxidized steel, silkscreen, and stainless steel on wood base. Left: section three. Right: installation view.

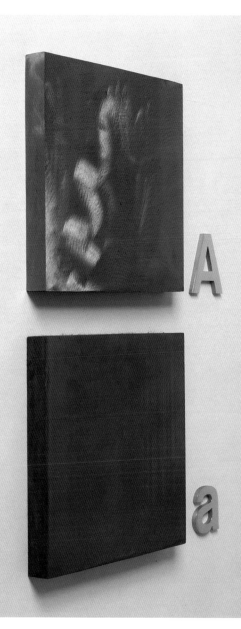

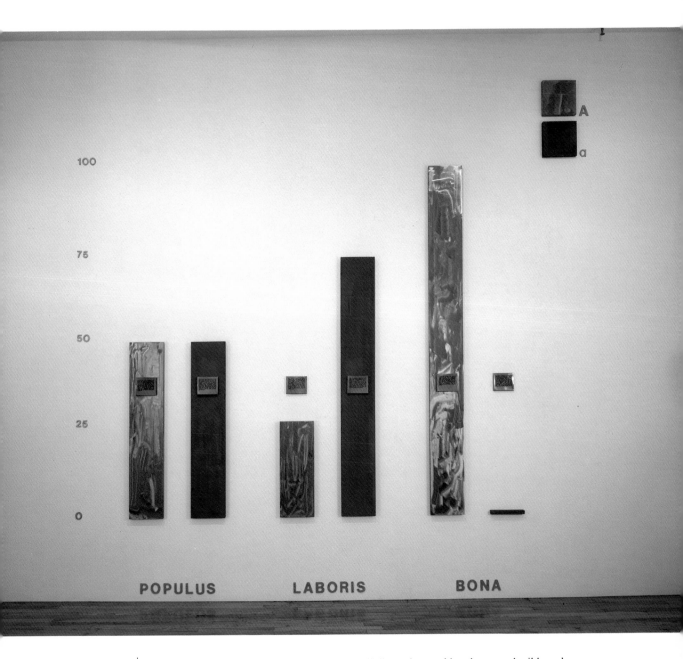

PART IV | **POTESTAS** 1989, 14 units, $100 \times 114 \times 2''$ overall dimension, etching, brass, and mild steel.
Left: detail. Right: installation view.

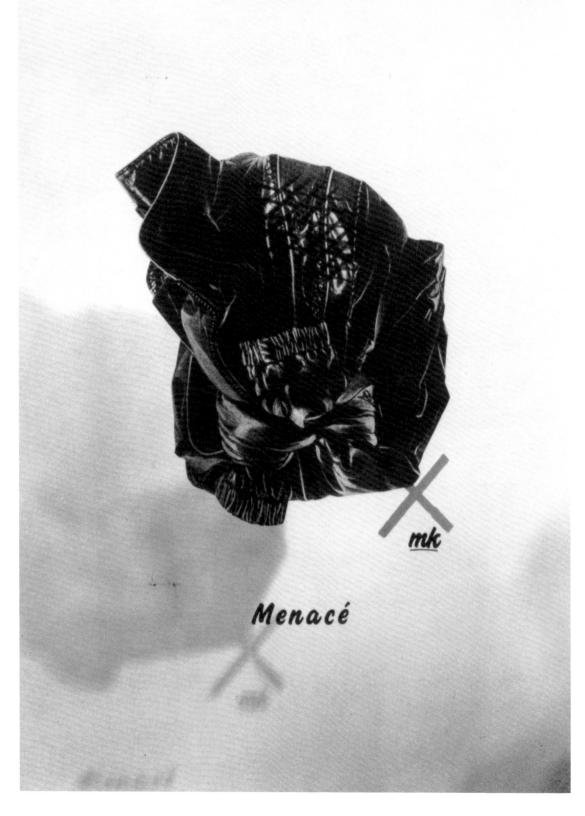

CORPUS | Detail from "Menacé" section, 1984–85.

There's a rebirth in America.

There's a renewal, a reaffirmation of values, a return to quality and quality
of life.

We have seen it approaching, we have felt it happening, it has begun to affect
our lives.

And now, suddenly, it is upon us full force.

To us it's a woman who has found her identity in herself, her home, her family.

She is the contemporary woman whose values are rooted in tradition.

"The New Traditionalist,"
Good Housekeeping Magazine ad series *

In the left foreground of an ad, a woman in what might be called casual collegiate
dress stands with her arms crossed, looking directly at the viewer. A child, sitting
isolated on the lawn in the middle distance to her right, ignores her and stares off to
the side. Squarely filling the background at the right looms a house. This woman is
familiar. I have seen her all my life in ads, on television, in the newspapers. She
scrubs the family bathroom clean with a smile, always prepares the perfect dinner,
holds sparkling glassware aloft, and takes the right medicine at the right time to
remove any sign of strain from her otherwise tidy life. Again a prominently displayed
wedding ring sends its reassuring signal. The absent husband, we're to assume, is at
work. And, although her thin, angular body and claw-like hands express a certain
tension, her expression is smug. Perhaps she's left a Wall Street job to return to the
domestic life. Whatever the reason, she has a superior, knowing, self-satisfied look.
"All is right with my world," she seems to be saying. "What's wrong with *yours*?"

This ad, one of a series called "The New Traditionalist" for *Good Housekeeping*
Magazine, has bothered me ever since I saw it in *The New York Times* a year or so
ago. Now that INTERIM, Mary Kelly's magnum opus, is being shown in its entirety
for the first time, it seems appropriate to try to locate what I find so troubling about
it. After all, the difference between the social construction of woman-as-object and

how she experiences herself in relation to this construction is at the heart of Kelly's
ambitious project.

17

The ad, then, is the very picture of order and control, a layered "diorama" whose apparent straightforwardness, even neutrality, belies the narrow ideology of its message. According to *Good Housekeeping*, the quintessential American Woman stands before her house like a sentinel. Cut off just below the hips, she's unable, literally, to go anywhere. The house itself, emptied of affect, is stark and bare; there are no flowers in the windows, no vines on the porch, no toys, bicycle, or swing to mar its pristine surface. The child, self-contained and self-sufficient, needs nothing. Here nothing whatsoever can *happen*.

And yet this woman hovers over me like the ghost of my mother, like a standard of perfection against which I will never measure up. She takes different guises, has a choice of dress styles: wife, mother, sister, daughter, friend, in T-shirt and jeans, a perfectly tailored business suit, or furs and evening gown. She is the mirror, in other words, into which I am to look to judge myself. Unlike me, though, she has no edges or contradictions, no flaws or inconsistencies. Created to emblematize a constellation of beliefs, she is constructed for someone's use and pleasure other than her own. Two-dimensional and mute, she is pure object.

Spare, with its component parts completely atomized, the image has the quality of an icon, a universal truth. It is meant to be all women and, as with all icons, the woman pictured is spoken for. The ad manipulates its readers by speaking arrogantly in the first person plural and by invoking nostalgia for the good old days before the Women's Movement. "We have seen it approaching, we have felt it happening . . ." presumes that the readers, a homogeneous body, having experienced the same phenomenon, agree with the ad's conclusion: that Woman's identity is located in the private institution of domesticity, in home, marriage, and child. The voice—of God, Legislator, Father—knows what it likes, and what Woman should like, too. It speaks to women prescriptively, with an authority no one else could possibly have, or would dare to presume.

Mary Kelly's INTERIM means to upset and displace this voice and its seductive logic. As she says, "The question I want to raise is, What is a woman?" Unlike the *Good Housekeeping* ads, though, she doesn't pretend to have the answer. Instead, her work is deliberately structured to encourage viewers to ask themselves some fundamental questions: How do we know who we are? How is our subjectivity— what we believe ourselves to be—constituted in and by the social order? And, finally, who is doing the constituting?

———

INTERIM examines the woman-as-subject as she enters middle age, a time when her increasing invisibility and powerlessness in the masculine world may lead her to experience vividly her own "constructedness." Conspicuously absent in most novels, films, and ads, the older woman is not considered sexy because she's no longer seen to be a useful measure of a man's potency. Because power accrues to a woman in a patriarchy by virtue of her body's procreative capacities and its potential for fetishization, the aging or aged female body becomes a relic, a site of loss. For

femininity
has to come
apart as a
construct

Kelly, this loss of power lodged in the body renders transparent the economic, political, and cultural conditions that deprive a woman of power—the very conditions which simultaneously keep her from her own subjectivity.

Weaving together divergent positions of relative distance and closeness, neutrality and engagement, fact and fantasy, from both a personal and political perspective, Kelly explores the relational aspects of subjectivity and objectivity. To achieve this, the "voice" used in INTERIM is necessarily disjunctive and multiple, a densely textured melange of different tones, different times, different positions. Structured on Brechtian principles, INTERIM is full of visual and linguistic interruptions that radically challenge the seamless nature and unitary terms of so much traditional artmaking. To structure a piece with the device of interruption is to produce a work punctuated with frozen gestures; without narrative continuity, discrete moments collide. As Walter Benjamin observed, an audience, deprived of traditional linear narrative, experiences not the usual empathy—the cathartic emotional release that results from an identification with the characters—but "[astonishment] at the circumstances under which they function."[1] To this end, Brecht's epic theatre offers "the representation of conditions rather than the development of actions."[2]

So does Kelly's INTERIM. As the work makes clear, it is the representation of conditions that defines women's subjectivity. For three years before she began to give form to the project, Kelly kept a notebook—an archive, as she calls it—in which she recorded conversations she had overheard or engaged in with women who were responsible for launching, or had been affected by, the second wave of feminism—the women, in other words, of 1968. Arranging her notes in various forms, she offers us the opportunity to hear these women as they explore their experiences as wives, mothers, sisters, and daughters, most of them from the vantage of middle age. In the process, we discover that we too are being encouraged to search and research our own histories and responses, an engagement which creates both a new definition of authorial power and a sense of pleasure in the interchange of subjectivities. As for Kelly's own subjectivity, the issues investigated in the work are clearly indicative of her own interests and experience, though INTERIM is not specifically autobiographical.

Mary Kelly began the work in 1983 while she was living in London. She isolated the themes which figured dominantly in the collected conversations and used them to organize the project into four sections:

Part I, *Corpus* [the body], pairs images and narrative panels on reflective plexiglass (white on black, with phrases and parts of the images picked out in red), in an arrangement of five groups, three pairs to a group. Each takes its title—"Menacé," "Appel," "Supplication," "Erotisme," and "Extase"—from the nineteenth-century French neuropathologist J.M. Charcot's *attitudes passionelles*, his classification of the hallucinatory phase of hysteria. The texts are hand-written, first-person accounts which explore how older women experience the body shaped socially and psychically by the discourses of popular medicine, fashion, and

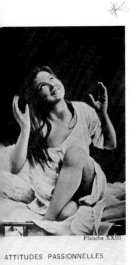

Planche XXIII
ATTITUDES PASSIONNELLES
EXTASE (1878).

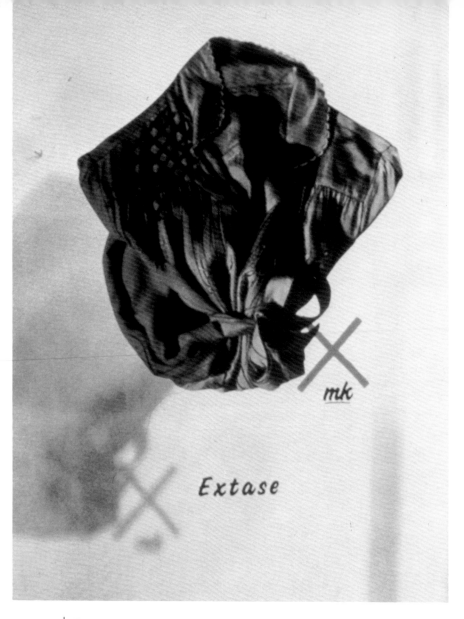

Extase

CORPUS | Detail from "Extase" section, 1984–85.

romantic fiction. The paired images are of articles of clothing (a leather jacket, a handbag, a black nightgown, and a white embroidered dress), arranged in increasing states of disarray.

Part II, *Pecunia* [money], adapted from the Latin proverb, *pecunia non olet*, or "money does not smell," consists of multi-colored, galvanized steel panels, fastened to the walls and opened like books to a reading of silkscreened texts. Divided into four sections, five panels in each, the work spells out the Foucauldian schema *mater*, *filia*, *soror*, and *conju* (or mother, daughter, sister, and wife, the subject positions of women within the family construct) sequentially on its "covers." Mixing first-person narratives, classified ads, and greeting card quips, this diaristic section charts the disposition of desire as it passes through the filters of a particular economic system and set of social relations. Its images and texts are slippery,

The white dress is part of a plot to escape. From what I'm not quite sure, but all through the cold, dark and indifferent winter I have been planning it. Learned academic by day; and by night, secret reader of holiday brochures and eater of maple sugar candy, planning how the three of us would meet in Miami, happy family reunited – father, mother, child, against a backdrop of blue sky and pounding surf of course. I have told no one. Finally, the day arrives. I pack the suitcase with devotion, the way a bride would do her trousseau: no jeans, no boots, no leather jacket or coat of any kind and nothing black, only brightly colored blouses, loosely fitting trousers, shorts, halters, high-heeled shoes and all the jewelry I ever wanted to wear and didn't have a chance to. And the dress. I refuse to wear a coat even to the airport in anticipation of the happy metamorphosis that will inevitably take place when I emerge eight hours later. And it does. The air is hot and thick. I feel it soldering the bits and pieces of my body into something tangible, entire. I can be seen, imagine men are looking at me, even look at them sometimes. Soon, they arrive, seem much shorter, fatter, whiter than I had remembered, but it doesn't matter, we are together, I am glad. What's more, today is Easter Sunday. Naturally, I'm wearing the white dress – simple, silk, embroidered bodice, gathered at the waist, full skirt falling just below my knee, and thinking, thank god no one will see me (I mean everyone is in New York) and wondering who am I wearing this for anyway. Not him, he doesn't notice and the prospect of negotiating Disneyland has already given him a headache. Then my angelic son tells everyone, "look at my Mommy." The riddle solved. I am transported in a halo of fluorescent light to the land of "good-enough mothers." The motel manager waves his magic wand and says, "Please come with me into the dining room where you will feast on champagne, strawberries and cream, the Seven Dwarfs will play the Brandenburg Concertos and I'm quite sure you will live happily ever after." And we do.

CORPUS | Detail from "Extase" section, 1984–85.

moving indiscriminately between fact, fiction, dreams, and sales pitch in much the same way television does. Real estate ads ("Magnificent contemporary villa, prime in-town hilltop acre . . .") are juxtaposed with tongue-in-cheek advice about making money ("What's the fastest way to make a million? Invent something"), and personal complaints and aspirations ("Someday, she wanted to write a book"). As Kelly says, *Pecunia* is about the "forms within which we structure our desires."

Part III, *Historia* [history], is a pseudo-documentary in the form of silkscreened steel pages, displayed flat, which materialize the metaphor of "making history." Its four narratives present, in Kelly's words, "the political body," as it is conveyed in the words of women who were 27, 20, 14 and 3 years old, respectively, in 1968, and who are reviewing their relationship to the Women's Movement. These texts are followed by two shorter sections, one of which describes moments of collaboration

and communication which result from women being able to "see" each other for the first time, and another which satirizes the exchanges of a group of women at a party who *can't* see each other because of the ways in which they define themselves by their ages.

Part IV, *Potestas* [power], is, of all of INTERIM's sections, the most straightforward in appearance. A monumental 3-D bar graph, it visualizes the information offered in a 1985 United Nations Report: "[Women], by virtue of an accident of birth, perform two-thirds of the [world's] work, receive one-tenth of its income, and own less than one hundredth of its property." In the process, *Potestas* conveys not only these statistics, but a strong sense of how cultures create hierarchies in order to validate the deployment of power, and how women experience their resulting positions.[3]

By mixing visual and semantic styles, INTERIM subverts easy, artificial oppositions like active/passive, subject/object, old/young, and true/false. At the same time, its method of splicing together "autobiography," romantic narrative, advertisements, fairy tales, and statistics confounds a linear or unitary reading altogether—an effect the piece's quirky humor has as well. The second section of *Historia*, for instance, is a witty indictment of women by women: " 'Amazing,' says No Lipstick. 'Tragic,' adds One Earring. Then, exchanging The Look of Utter and Tragic Amazement, they proceed with their complaints." This kind of turnabout unsettles any complacency a viewer might feel who simply identifies with women as "the oppressed."

It is probably clear by now that INTERIM doesn't look much like traditional art. It's obviously not painting, sculpture, photography, or graphic work in any generally accepted sense, though it has elements of all of these. In fact, its reliance on texts has led to the complaint, "There's so much to read!" But Kelly uses language in an effort to avoid being trapped or trapping the viewer in the structures of visual dominance which have characterized the representation of women throughout history. It is a strategy which also enables her to explore how the restrictive business of naming and categorizing narrows what life there is available for women to live. Latin, for example, functions in INTERIM as a distancing mechanism by distracting the spectator from a word's literal meaning, in order to underline its structuring capacities and to subvert the apparent neutrality of our social arrangements. This focus on "woman's command of language as against language's command of woman" is critical to Kelly's work.[4]

Monolithic conceptions of gender, sexuality, race, and class are also deconstructed in relationship to the history of feminism by INTERIM. It becomes clear from a reading of *Historia* that what we refer to as the "Women's Movement" is hardly a fixed moment or a uniform experience—that no single story can represent it. In the United States, the renaissance of feminism was, in my experience, an epiphanous moment from which no participant emerged unchanged. Lives were altered dramatically in very short periods of time as long-term relationships were violently torn apart, families broken, friendships polarized, and jobs lost. In small groups,

many of us explored our histories, authorizing ourselves and our experiences, tracing our legacy of personal and social oppression. In larger organizational networks, political empowerment was sought through legislative and judicial change.

But history to Kelly is not confined to the events of the last twenty years. In her analysis, another, far older, history finds itself comfortably allied with the ideology of hysteria, the nineteenth century's "womb madness" to which women were thought susceptible.[5] It is the history women have of being defined by their reproductive capacity. It is the "hystery," so to speak, by means of which women's identities are consciously and unconsciously tied to their appearances. The cost to women of such a legacy, as feminists have discovered, has been their own subjectivity.

To consider the womb as the site of patriarchal ownership and control is to render the question of women's subjectivity from still another position. The most viable form of power a woman now has comes from being a mother, from the fulfillment of her so-called "natural" function. In this capacity, she is presumed to have superior knowledge—and so authority—and is allowed control in the domain of childrearing and related domestic matters.[6] As *Good Housekeeping* makes abundantly clear, motherhood is the "real" business of women and they are best kept busy at it.

Kelly's earlier, much-discussed work, POST-PARTUM DOCUMENT (1973-79), was the record of her own history of motherhood during the first seven years of her son's life. This piece made literal fact out of the feminist assertion that the personal is the political. Her meticulously documented study of the child's individuation and entry into the gendered world of language and representation acted to prove that motherhood is itself a subject position since, while mothers respond to the needs of their infants, they need their infants as well. But motherhood as a position of subjectivity is invisible in public discourse: that is, in medicine, fashion, law, art, and so on. As a result, the DOCUMENT was extremely controversial when it was first shown. After all, no "serious" artist would dream of making a work about mothers and babies.

And yet women's most visible and available identity remains that of Mother, as "The New Traditionalist" ad with which I started my discussion is so pleased to trumpet. The pressure to submit to the singularity of such an identity is implicit in representations of all kinds, as Kelly's piece indicates. Woman, for example, is born into language, which represents her to herself as already known; she sees herself in thousands of images which tell her it is better to be young, beautiful, rich, thin, and sexy; she is encouraged, cajoled, urged, and/or forced to take the measure of herself from these "pictures." To ignore them is to run the risk of disappearing. To refuse them is to be asked to atone, in a sense, with her life.

———

The raging questions at the heart of Mary Kelly's work are: How can women become visible and effective? How can they encode their subjectivity into

discourse—become *present* in the world? And, finally, what form will their power and authority take?

Powerful women—government leaders, heads of multinational corporations, university presidents, Supreme Court judges, editors of influential newspapers and journals, major philanthropists—are still the exception, not the rule. While there are more of them today than there were fifty years ago, they still constitute a very small minority of the forces shaping Western society. And though more women than ever before are occupying a larger percentage of middle-management positions, there remains precious little room at the top. This is one reason why so many successful women have left the male-dominated workplace to head their own businesses or companies.

When women do choose to compete within the existing structures, they very often are forced to ally themselves with the status quo as a survival strategy—to become, in other words, "one of the boys." Those who assimilate tend to see themselves as exceptions; they may sympathize with the plight of other women, but they feel themselves to be distanced, privileged, and often superior insiders. It is this attitude which assures that the status quo will be maintained. And even women who choose to play the game can find themselves in conflict about the power they gain in the process, sensing the price they pay to be their own betrayal.

Whether women form alternative organizations, repeat dominant power relationships in reverse with an all-female cast, or attempt to enter the workplace on "equal" terms, they echo the ambivalence of a society that, for the most part, finds powerful women desexualized, emasculating—altogether inappropriate and terrifying. But we give ourselves over to power as much as it demands submission. By including in INTERIM the conflicted voices of women longing for another way of life but unable to choose it, Mary Kelly recognizes and acknowledges women's own complicity in the inequities of the existing social contract. For, just as it is hard for critics to understand the ways they are implicated in the systems they critique, it is hard to recognize and acknowledge one's own complicity in the process of subordination—or domination. Power is seductive as well as repressive.

From this tangled web of power, a fruitful alternative is emerging and it is one to which the visual and theoretical formulations of INTERIM would seem to lead. It is the possibility, proposed in different ways by feminists such as Julia Kristeva and Jane Gallop, of relinquishing authority from a *position* of authority. As Gallop says, "One can effectively undo authority only from the position of authority, in a way that exposes the illusions of that position without renouncing it."[7] "But we never had any authority," women say, "so how can we give it up?"

But there are other ways to answer Gallop's call. The use of structural or institutional models that are neither imitative nor exclusive is still a rarity in this country, but it does exist. Examples can be found throughout the United States in collaborative community action groups, women's self-help collectives, alternative schools and nursery programs, and neighborhood building initiatives, among others.[8]

Mary Kelly's work itself provides an alternative mode of artistic practice which uses other, less authoritative forms of representation. As critic Gillian Beer so succinctly argues, without this practice,

> *representations rapidly shift from being secondary to being primary in their truth-claims. . . . Representations . . . become representatives—those empowered to speak on behalf of their constituency. . . . That is where the trouble starts when the claim is representing women: speaking on behalf of women—speaking on behalf of whom?*[9]

Kelly relinquishes the authority of the artist as a unique and privileged creator of meaning by incorporating many voices, in a variety of styles, and from a variety of positions, into INTERIM. In so doing, she opens a space in which the viewer can experience a kind of freedom of exchange with the work which is exhilarating.

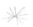 At the same time, her work is part of the larger, many-leveled feminist project of naming what has not been named, writing what has escaped being written, making visible what has never been seen. Its aim, simply, is to unloose the ties that bind.

NOTES

** We have yet to receive permission from Good Housekeeping Magazine to reproduce the ad mentioned in this essay.*

My thanks to Eunice Lipton for her insightful, critical reading of this essay, and for her many helpful suggestions.

1. Walter Benjamin, "What is Epic Theatre?" in *Illuminations* (New York: Schocken Books, 1969), p. 150.

2. Walter Benjamin, p. 150.

3. *Potestas* is incomplete as of this writing (October 1989); descriptions of it are based on information provided by the artist.

4. Sandra M. Gilbert and Susan Gubar, "Sexual Linguistics: Gender, Language, Sexuality," in *The Feminist Reader: Essays in Gender and the Politics of Literary Criticism*, ed. Catherine Belsey and Jane Moore (New York: Basil Blackwell, 1989), p. 85.

5. Griselda Pollock, *Vision and Difference: Femininity, Feminism and the Histories of Art* (London and New York: Routledge, 1988), p. 189. Pollock's analysis of *Corpus* in relation to psychoanalysis and photographic representation is especially illuminating.

6. Although for men there is neither power nor social position to be derived from parenthood, they have nevertheless usurped women's autonomy in this area, too. For the most part, it is they who make the decisions concerning women's reproductive rights, the process of childbirth itself, and the outcome of custody battles. And, ironically, most of the "experts" on childrearing and development remain men.

7. Jane Gallop, *Reading Lacan* (Ithaca and London: Cornell University Press, 1985), pp. 19, 21.

8. The New Museum has also been struggling to create such a structure since its inception. It is only in the past few years, and with considerable difficulty, that we have approached a collaborative, self-critical, and "transparent" organizational model, which is still (and perhaps will always be) in the process of defining itself.

9. Gillian Beer, "Representing Women: Re-Presenting the Past," in *The Feminist Reader: Essays in Gender and the Politics of Literary Criticism*, ed. Catherine Belsey and Jane Moore (New York: Basil Blackwell, 1989), p. 64.

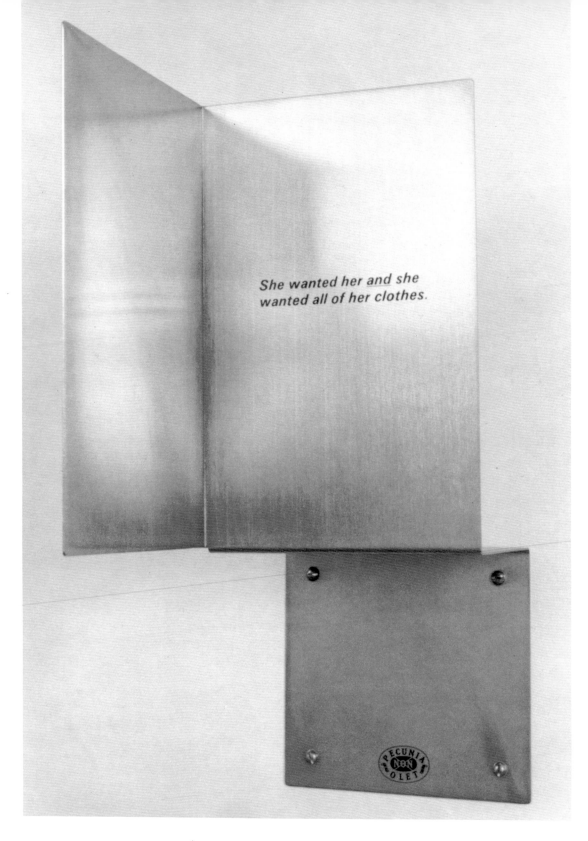

She wanted her and she
wanted all of her clothes.

PECUNIA | Detail from "Soror" section, 1989.

INTERIM AND IDENTIFICATION | NORMAN BRYSON

INTERIM is a work about identification.[1] Or, rather, about a crisis in which the female subject "of a certain age" finds herself stranded between roles and identifications, none of which appear any longer to fit her situation. Mary Kelly's earlier POST-PARTUM DOCUMENT had involved an excess of identification. The status of motherhood being so crucial a social role, the forces committed to constructing the maternal were massive and convergent: the discourse of science (or pseudo-science) as it weighed and measured, subjecting the mother and child to quantification and taxonomic description; the discourse of psychoanalysis, circling around the mother-child relation and absorbing it into its explanatory framework; and the force of the mother's own voice, bringing the experience of the maternal out of the recesses of the inexpressible and into a public domain of speech, image, and representation. The position of the mother in POST-PARTUM DOCUMENT, if it was not unitary, was at least "full": the sense of the state of motherhood as momentous in the life of the individual, and as a crucial object for social discourses to construct and make sense of, had been so strong that the autobiographical mode seemed appropriate and even inevitable.

But in INTERIM the autobiographical mode has lost its fullness and its rationale. *Corpus*'s narrator is one who is no longer spotlighted center-stage in the theater of identity, but has moved instead into dim, obscurely specified terrain somewhere in the wings. Before, identification was overdetermined; it existed as a condition of *pressure*: the outside pressure of social agencies crowding in on the maternal; the pressure from within, in the mother's need to speak her condition; and the pressure of time, impelling her to speak at once, to record each day and each unique event straightaway before the past moved in to turn the living traces into memoir and memorabilia. Now, the pressure is gone. No social agencies step forward, like suitors, to claim the woman of middle age; time no longer urges, it hangs heavy. Identification enters on a period of vacuum and dearth. What is striking now is the stark condition of *need* for identification. INTERIM takes this need and analyzes its vicissitudes, its passion, its avidity.

It is here that the perspective shifts from the personal to the social, from self-portraiture to the genre of history painting. For the passage from a femininity that

could be regarded as full, as an essence that needed only to disclose itself, and in a language that spoke directly from the female body, this progression to an analysis in which femininity appears as a construction, a kit, a box of prefabricated personae, reflects in a sense the collective history of a certain evolution within feminism itself, in the years between POST-PARTUM DOCUMENT (1973-9) and INTERIM (1984-9). It is not only the woman of a certain age who may experience sexual identity as an assemblage of moving parts and positions; the implications extend far beyond the work's "personal" subject.

AGAINST THE
DOMINANT REGIME

Both POST-PARTUM DOCUMENT and INTERIM bear the traces of one of the key problems facing the artist who deals with issues of cultural identity: how to show the role of the visual in constructing that identity without falling back into the dominant circuits of identity that flow through image and spectator in the space of the gallery. As we know, these circuits have been historically moulded to produce certain directed outcomes:

> *In a world ordered by sexual imbalance, pleasure in looking has been split between active/male and passive/female. The determining male gaze projects its fantasy onto the female figure, which is styled accordingly.*[2]

Within this circuitry, the position of the female spectator has been anomalous, and that of the female artist almost a contradiction in terms. It is one thing for a cultural critique to expose and analyze this situation in the medium of language—but quite another when the medium is visual. How can the artist work to break the circuit that assigns to the male spectator the role of voyeur, and presents to the female spectator the grim alternatives: identify either with the gaze, the male voyeur, or with its objectification, woman-as-image? The problem here is how to find ways to resist the positioning of the female viewer in the terms dictated by the dominant culture. Like POST-PARTUM DOCUMENT, INTERIM mobilizes a number of strategies. Three in particular deserve comment: a resistance to voyeurism through the use of what might be called "the aniconic body"; word/image crossing; and citation.

THE
ANICONIC
BODY

It is essential to *Corpus* that no further images of the female subject will be supplied: the iconic register of the image is largely evacuated. If visual pleasure is to be understood and analyzed, there must be a distancing effect, a Brechtian *gestus*, which will interrupt the classic visual text's endless servicing and pleasuring of imaginary relations. Thus in POST-PARTUM DOCUMENT one sees no picture of the mother; no Madonna-and-Child will be found. And despite its autobiographical tone, *Corpus* provides no self-portrait of the narrator. What the work seeks out instead are the mechanisms by which the subject tries to portray herself, to make herself into an image, a "self"-image. What *she* experiences is the fantasm: the ideal ego. What we see is the forlorn material base on which the compensating fantasy images are built: a black leather jacket, a handbag, shoes, a summer dress, a

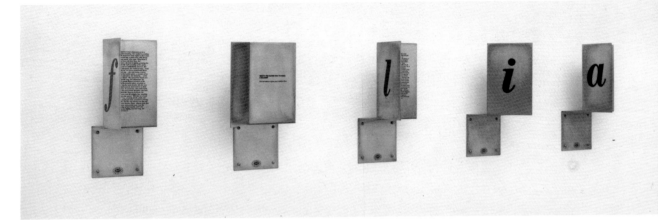

PECUNIA | "Filia" section, 1989.

nightgown. To be more accurate, the base is only incidentally material: the bits of costume out of which the ego builds its magnificent imago are already half-dissolved in the translucency and magic of the ego's transformation scenes. Semi-transparent photographic images applied to panels of perspex render the clothes substantial and shadowy at the same time. As substance, they reveal the real conditions, the material substructure on which the ego builds its identifications, an economic base determined by the commodity and the fashion industry. As shadow, or as substance passing into shadow, the photographs act out the way the clothes are deliquesced to produce a real (that is, a fantasmatic) identity.

WORD/IMAGE
CROSSING

C.S. Pierce speaks of three families of sign: the icon (pictures, photographs); the symbol (words, numbers, arbitrary signs); and the index (the sign made by natural processes: the symptom as the sign of a particular disease; smoke as the sign of fire).

INTERIM is suspicious of iconic signs. It is as though the iconic aspect of images of women has become so irrecoverably compromised, so worked to death by cultural manipulations, the only way forward is to renounce it altogether. (This is the point of difference between Mary Kelly and Cindy Sherman, who, following the opposite strategy, overloads the iconic to the point of breakdown.) In Mary Kelly's work, the iconic has the status of the unviable: it is where the imaginary tends to become hypnotic, and where—in so far as INTERIM is a *Lehrstück*—the trance must be broken. Jean Baudrillard has observed that while in classical culture what supplied the unity and identity of the subject was the soul, now it is the body, and that it is a body "entirely positivized by sex . . . and not . . . divided and split by sexual difference" which in contemporary visual culture is shown.[3] By saturating the body with signs of sexual difference and by interpellating the subject *as* this body which is so marked and governed by the iconography of gender, contemporary culture plays upon the imaginary and builds the subjects of (and in) sexuality.

29

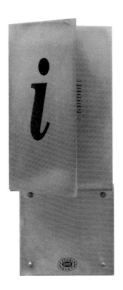

To dissociate the visual from its circuitry, *Corpus* exits from the iconic in two major directions. The first involves the inscription: accompanying the images and interposed between them are texts. Yet these texts are also in their own way highly "visual": they hang on the walls like paintings, dramatizing the unfolding of their calligraphy. Where mere opposition of word to image would risk leaving intact the authority of the image (as a foil or contrast to verbal signs), the *hybridization* at work here renders it impossible to find a "pure" image, a distinct iconic register, in the whole work.

The second exit leads towards the index, the sign that connects with natural processes: the indexical stays close to the real world. The handwritten texts in *Corpus* place the image in relation not to some far-off Platonic space of abstraction (the symbol), nor to some impossible space of imaginary identification (the icon), but rather to the body making the artwork. One is made aware of the hand of the artist as it traces the unique shapes of a personal script.

All of these sign-forms have their attendant dangers. The risk of the icon is that of carrying the viewer off to the imago and hypnosis. The risk of the symbol is that of annexing the spectator to abstraction, authority, to the Law. And the risk of the index is its suggestion that it somehow retains a natural and essential connection with the personal, with unmediated self-expression. In INTERIM, though, no single form is allowed to dominate. Instead, a complex, heterogeneous sign is produced which is able to resist what each sign-type might lead to by itself: specularity (the effect produced when the iconic governs an image); subjection to the Law (the effect produced when the symbol predominates); and the romance of self-expression (the effect produced when the index is determinant).

A key move in INTERIM is to mix the families of the sign to such an extent that no clear *picture* can be found. Above all, this ensures that the spell of the icon is broken. What one finds instead are the icon, symbol, and index crisscrossing each other's domains so insistently, the iconic can no longer dictate the terms of the visual field. As proof that "the image" is not reducible to its figurative register, this new multiplicity also points the spectator towards what is nonspecular in the field of vision. It is here the female spectator may be able to escape the specular imperatives and double binds of dominant visuality: to be either an object (an image, an icon) or a voyeur (a male voyeur *en travesti*).

CITATION In *S/Z*, Barthes wrote of the *doxa*, the received wisdom which social subjects commonly share, the montage of platitudes, stereotypes, and *idées reçues* by which the realist text rhetorically fashions its "effect of the real." In INTERIM, the *doxa* are the materials from which the subject of culture constructs its "inner speech," its stream of consciousness. The assumption here is that "discourse" inhabits the recesses of subjectivity no less thoroughly and pervasively than it does the external, outer world. Traversing the divide between public and private, the personal and the political, discourse operates both "out there" and "in here"; it is the very principle

of interflow between outer and inner domains, a Möbius strip which on one side reads "self" and, on the other, "world." The diary-like entries of *Corpus* may be thought of as analyses that sift or scan inner speech for certain particularly charged formations of subjectivity, and assign them to their respective sources. In *Corpus*, the sources singled out are popular medicine, popular fiction, and fashion.

But these citations from inner speech are not all equal. The work organizes them around distinct levels, from an "upper" tier of lucidity and consciousness, down through various forms of confusion and perturbation, to the unseen depths of the subject's bodily and unconscious life. The most lucid of these levels is INTERIM's own analysis of subjective discourse, the result of a piecing together of patterns of inner speech from over a hundred conversations with different women. Next in closeness to the functions of a wakeful and critical consciousness is the voice (or hand) that speaks (or writes) the texts. As a voice, it is even in tone, self-possessed and homeostatic. No matter how painful the experience it recounts, its syntax binds all the contents together; everything is coverted into the same polished and polite surface. As a hand, it tends in the same way towards evenness and liaison: the letters are drawn on the transparent surface at the same careful pace; there is no quality of *tremolo*, of the seismographic. Even when the content is traumatic, the graphic apparatus goes on producing its even, copybook script.

Moving away from this display of vigilance and self-control, the work presents the next level of inner speech, that of the *interruption*. Here the voice can no longer articulate the discourse into syntactic smoothness, and the hand trails:

> *want to dance . . . see myself . . . images grate . . . clothes . . . hair . . . expression . . . arms . . . hips . . . feel silly . . . everyone here so Goddam young . . . reduced to a voyeur . . . hate them . . . turn them [] into frogs and vanish.*

Something is breaking into the discourse and stopping its path; the words are jammed between ellipses, as though to silence material which cannot be expressed. In the texts, blocks of red traced behind the words indicate the presence of particular libidinal charges and investments. In the images, red accents indicate "danger" zones and sites of hysterical cathexis. And, finally, there is the level furthest from consciousness and speech, the level into which all three discourses— popular medicine, fashion, romance—descend: that of the body and its drives. In this aniconic system, it is not a body that can be directly stated; its drives do not appear within representation, but rather *lean* on it, energize discourse—and at times block its flow.

The texts of *Corpus*, then, act as an apparatus at once graphic and psychic, a mystic writing pad. Behind and invisible are the unconscious, the body, the drives. What we see written is only that surface which can be presented to the conscious mind. An evenness of voice and hand fills out the lacunae and regulates the syntax by a kind of secondary revision; while, watching over the whole graphic surface,

there hovers a vigilant point of analysis and judgment, a higher faculty of surveillance or superego, the spectator, ourselves.

IDENTIFICATION INTERIM is a work that centers on questions of identification. But what is identification? What is meant by this term in psychoanalysis?

There are no easy answers to these questions and, in fact, the theory of identification remains one of the least developed areas in psychoanalytic thought. But one can readily distinguish between two approaches to this terrain, approaches associated on the one hand with ego psychology (Hartmann), and, on the other, with the *école freudienne* (Lacan). The gulf between them is vividly dramatized in the following conversation between Isabel Archer and Madame Merle, in Henry James' *Portrait of a Lady*. Madame Merle is of the opinion that the self is made up of "some cluster of appurtenances":

> *"When you've lived as long as I you'll see that every human being has his shell and that you must take the shell into account. By the shell I mean the whole envelope of circumstances. There's no such thing as an isolated man or woman; we're each of us made up of some cluster of appurtenances. What shall we call our 'self'? Where does it begin? Where does it end? It overflows into everything that belongs to us—and then it flows back again. I know a large part of myself is in the clothes I choose to wear. I've a great respect for* things! *One's self—for other people—is one's expression of one's self; and one's house, one's furniture, one's garments, the books one reads, the company one keeps—these things are all expressive."*

Isabel takes exception to this point of view:

> *"I don't agree with you. I think just the other way. I don't know whether I succeed in expressing myself, but I know that nothing else expresses me. Nothing that belongs to me is any measure of me; everything's on the contrary a limit, a barrier, a perfectly arbitrary one. Certainly the clothes which, as you say, I choose to wear, don't express me; and heaven forbid that they should!"* . . .
> *"Should you prefer to go without them?" Madame Merle inquired in a tone which virtually terminated the discussion.*[4]

This conversation between Isabel and Madame Merle expresses, as a comedy of manners, a division in psychoanalytic thinking which can be traced back to Freud himself. There are many texts in which Freud maintains that when the ego identifies with something outside itself, it *absorbs* (incorporates, introjects) that outer object into itself. The object may assume a number of different forms. Crucially, the ego of the child identifies with—and societal pressures enjoin it to sustain the identification forever—the parent of the same sex. This primary identification is the most thorough-going and definitive for the subject since it is through the assimilation of the imago of the mother (for the girl) and the father (for

the boy) that the subject lays the foundation upon which all its subsequent elaborations of gendered identity will be built. Yet not all identifications possess this definitive structuring function. There are also partial identifications with traits, such as those assimilated to the subject from others; or fleeting identifications with aspects of another's image (central to the experiences of fashion and narcissism, which *Corpus* explores); or identifications with the *position* of another, for example, with positions in the family of the kind presented in *Pecunia* (*mater, conju, soror, filia*).[5]

But concerning the actual dynamics of identification, Freud's texts are famously contradictory. Much of the time it appears that the ego is a predatory agency, unified and imperialistic. In "Instincts and their Vicissitudes," this ego is described as ingesting those objects in the outer world that it desires; what it does not desire, it distances as external and inimical.[6] And in the essay "On Narcissism: An Introduction," Freud uses the image of an amoeba to figure the process by which the ego carries out its incorporations:

> We form the idea of there being an original libidinal cathexis of the ego, from
> which some is later given off to objects, but which fundamentally persists and
> is related to the object-cathexes much as the body of an amoeba is related to the
> pseudopodia which it puts out.[7]

Such emphases point to an Isabel Archer-like understanding of the ego's activities: the "self" experiencing a boundary or ring around itself which clearly divides the interior from the exterior, or self from world. The cluster of appurtenances surrounding it exists, then, entirely on the outside; as Isabel puts it, "nothing else expresses *me* [emphasis added]."

But at other moments in Freud's writings, it seems that identification names something radically different from this work of colonization and assimilation, this stretching out of pseudopodia towards the point or object the ego desires, and pulling of the desired object inside the ego's own boundary or skin. Mikkel Borch-Jacobsen writes of another tendency in Freud's texts to describe the ego as an agency without center, simply as the *movement* from one point of identification to the next, across the whole "envelope of circumstances."[8] Madame Merle's phrasing is precise: "[The ego] overflows into everything that belongs to [it]." In this other, more disquieting model of identification, the self actually exists at and as the sites to which the ego is drawn ("I know a large part of myself is in the clothes I choose to wear"). In *Corpus*, those sites are the discourses of fashion, popular medicine, and romance; in *Pecunia*, the roles or positions of mother, daughter, sister, and spouse.

The "self" implied by INTERIM as a whole is one that exists *across* identifications and traverses a whole array of sites and discourses which construct and sustain subjectivity, not one which absorbs these back into its own coherent and organic unity. INTERIM is a work of which Madame Merle might have approved. Yet this

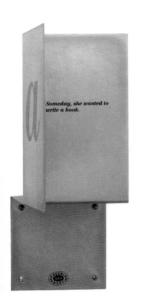

Someday, she wanted to write a book.

Norman Bryson

2

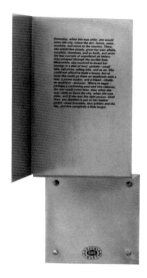

motion of self or ego—the self or ego that is this motion from one site of identification to the next—is by no means free to go off wherever it likes. The social formation surrounding it permits only limited maneuver between distinct and preestablished sites. In *Pecunia*, there are just four of these, and, in *Corpus*, a comparison is made between the social positioning of the female subject of middle age, and the women patients J.M. Charcot wheeled in to demonstrate to his audience at the Salpêtrière the five "passionate attitudes" of hysteria. Freudian thought insists on identification's dynamism and mobility: in "A Child is Being Beaten," Freud shows the subject moving across a whole spectrum of possible positions within the fantasy he analyzes. But in INTERIM what is stressed is the *blocking* of such motility, the narrow range of available alternatives, and the social manipulations that direct the subject between precisely designated discourses and sites of identification.

In *Pecunia*, for example, the force behind both mobility and immobility in identification is money. On the one hand, money promises the subject freedom to move out into the world and to model the world according to its wishes—the universal fantasy of making a million dollars. On the other, the fantasy of riches plays instantly back into the commodity system and rigid patterns of consumerism. In the subways of New York, there is currently a poster campaign advertising a lottery, in which individuals are asked to say what they would do with the loot if they won. *Pecunia* is like that: one sees the same flipping back and forth between liberty and imprisonment, the same freedom to fantasize turning instantly back into the tracks of banality and routine, and the fixities of prescribed identity. The forces holding the subject in position are not simply psychic, or even social, but are produced—INTERIM argues—exactly in the interlocking of these two systems, the psychic being just *another level of inscription* within the social and economic construction of subjects.

DISAGGREGATION Like *Corpus*, *Pecunia* uses the modes of fiction to present and to analyze major positions within subjectivity. And, traditionally, fiction has been credited with the capacity to enter into the truth of subjective experience through sympathy, empathy, and pathos. But the fictions in *Pecunia* are not intended to transport the viewer into the inner truth or world of another being—as though that would be to use art once again to extend the empire of the imaginary. What they seek to expose is the constructedness, not the flesh and blood, of *Pecunia*'s "characters," and to reflect or project that constructedness back onto the viewer.

It is not that these fictions—the little stories of the mother, wife, sister, and daughter—lack the usual signs of "realism" (the texts abound in the detail of the everyday, their ear for contemporary speech as sharp as Pinter's or Mamet's). It is rather that the textual details do not congeal into figures, individuals with whom the viewer may identify. Quite the reverse: What is discovered behind the novelistic surface is a schematic of the character, a geometry of possible subject positions.

34

It is here that *Pecunia* exercises to the full the (largely unused) semantic possibilities of minimalist space. Minimalism is known for its historical refusal of the center: instead of a focus, a core, a kernel of presence, it confronts the viewer with a decentered space, a *différance* of space in which the possibility of reaching a central zone is always deferred. *Pecunia*'s space does not consolidate around its four characters, nor are these four allowed to appear as "facets" of a single self or life (INTERIM, as a whole, has nothing in it of the confession). Instead, the force of spatial repetition breaks each "character" into constituent elements. Thus the Mother (in the supermarket episode) is less a narrative figure than a site crossed by the semes of escapism, duty, routine; in the restaurant episode, the semes are complacency, desertion, and bitterness. Though tied together by the unities of time and place, by consistency of tone, and by narrative "probability," the semes are separated by the force of the sculpture's spacing—what the text unites, the minimalist space pulls apart. The energy of that space is fissile; the illusion of a character, of pathos, is undone by its drive towards disaggregation.

This coming-apart is marked linguistically by the decomposition of the name into its component letters; spatially, it is dramatized by the spreading out of the individual letters across the repeated form of a "metal book"; and, economically, the disaggregation is glossed as the devolution of the person into an assemblage of commodities ("Gourmet kitchen, Gaggenau range, Subzero refrigerator . . ."). It is this economic twist in *Pecunia* that pushes minimalist space beyond its own received limits. For within minimalism, the problem has always been that, however much a work itself invoked repetition and spatial *différance*, in the end its field was pulled back together by the fact that everything was destined to reunite in the context of the gallery as an artwork, a commodity, an *objet de luxe*. What the work fractured, the market reunified; the centripetal force of the commodity could not be easily escaped. *Pecunia* knows this problematic well, but it also knows that the commodity's powers of conferring wholeness and unity—upon objects, upon persons— are largely unreal. To be sure, within the commodity's imaginary field, all these objects say "I": "Through the things I use, I express myself; this is my personal style and touch." But step slightly outside the cocoon of consumption and all these objects revert at once to junk, to personal waste.

What force *could* hold together this heap of miscellaneous goods ("Capodimonte china platters, vases, pedestals, gaming equipment, oriental rugs . . .")? If ownership is the effort to unify the field of commodities into a personal nest or habitat, that effort constantly comes up against the inherent tendency of commodities to disassemble, to revert to so much rubble and debris. But where minimalism has been compromised by the logic of the commodity, in *Pecunia* that logic is turned against itself: when objects are commodified, it reveals, they lose their coherence, their centering upon the person, and break up into so many shards.

Pecunia brings into alignment three powerful forces: minimalism's ability to disunify space; the commodity's to disaggregate the object field; and the critique's

capacity to separate subjectivity into its constituent structures. Here these forces echo and triangulate one another: spatial position, economic position, subject position. It is a work which asks: If we were to conceive of money and subjectivity in spatial terms, what would be the result? What does the *space of the subject* actually look like? In three dimensions?

READING
AS A MAN

Although I cannot know what it is like to experience INTERIM as a woman, it is a work in which for once I am not required to be a voyeur. The exhilaration which comes from this is followed, however, by an uneasy sense of voyeurism's persistence. For, in a sense, the regime of male spectatorship is present everywhere; it is the pressure INTERIM wards off and resists through its strategic work and intervention. I am, then, still in my old capacity as bearer of the look. But I find it inoperative: the work is forcing us to separate; I am being cast as the look's *outside*, as what it surveys.

Since INTERIM deals only with positions that exist for the female subject, the male viewer might well expect to feel excluded, plain and simple, from the work's field of vision. If INTERIM's voice had been vocative, if it had addressed the spectator directly as "You!" it would have certainly proposed and assumed the spectator as female. But, in fact, the work's modes of address are multiple and plural. This is an important difference between Mary Kelly and Barbara Kruger; whereas in Kruger's work, the viewing position tends to be defined by interpellation, INTERIM avoids the vocative register (*Corpus* is written in the first person, *Pecunia* in the third); invocation is everywhere avoided. Although the female spectator may be better placed to judge the cogency of INTERIM's analysis of subjectivity, the distance installed between the spectator and gendered experience is such that the work is unlikely to "ring true to experience" no matter who is doing the looking; it, after all, is meant to undo the unity and simple givenness of experience, the *étant données* of female subjectivity.

It is in this diffraction that the male spectator is most positively implicated in INTERIM's strategies. Had the work spoken directly from a "repressed femininity," things might have been different. Then the male viewer would have been faced with alterity—"That is her experience, this is mine; there is no overlap." But, instead, female subjectivity is broken up, disaggregated; it is known as constructedness and fabrication. And what is reflected back to the male spectator is the injunction to experience the positions of the masculine, as well, as cultural constructions.

Gender is our necessary masquerade, a production (in the theatrical sense) without curtain call, a drama into which we as subjects of either sex awake and must play until the day we die (on stage). But our history has been such that it has been women, not men, who have been the first to see through the masque, even though it remains the case that, when it comes to recognizing the social constructedness of sexual subjectivity, male resistance is intense to the point of disavowal: we know

36

that the masculine is only a fabrication, and yet. . . . INTERIM opens up the possibility for the male spectator to experience, perhaps for the first time, a visual field in which the business of fabrication is clearly laid out, with all its props and costumes, its cues and entries, fully exposed. If it grants him a place, it can only be through a complete restructuring of the foundation on which the male gaze has so far been built, a reading which must, to be successful, inaugurate a new kind of male visuality aimed at our divestiture.

NOTES

1. At the time of this writing only the first two parts of INTERIM (*Corpus* and *Pecunia*) had been shown.

2. Laura Mulvey, "Visual Pleasure and Narrative Cinema," *Screen* 16, no. 3 (Autumn 1975): 6-18.

3. Jean Baudrillard, *For a Critique of the Political Economy of the Sign* (St. Louis, Missouri: Telos Press, 1981), p. 97. See also Margaret Iversen's fascinating discussion of specularity in the work of Mary Kelly, Cindy Sherman, and Barbara Kruger in "Fashioning Feminine Identity," *Art International* (Spring 1988): 51-7.

4. Henry James, *Portrait of a Lady* (New York: Dell, 1961), pp. 190-1.

5. On identification in Freud, see Jean Laplanche, *Life and Death in Psychoanalysis* (Baltimore and London: The Johns Hopkins University Press, 1985), pp. 79-80.

6. "It seems the external world, objects, and what is hated, are identical. If later on an object turns out to be a source of pleasure, it is loved, but it is also incorporated into the ego; so that for the purified pleasure-ego once again objects coincide with what is extraneous and hated." *The Standard Edition of the Complete Psychological Works of Sigmund Freud* (London: Hogarth Press, 1953), vol. 14, p. 136.

7. *Standard Edition*, vol. 14, pp. 75-6.

8. Mikkel Borch-Jacobsen, *The Freudian Subject* (Stanford: University of California Press, 1988).

Illustrations on pp. 30, 33, and 34 are from the "Soror" and "Filia" sections of *Pecunia*.

I58 KELLY136
A-Folio
15/6/89
MODE H ON

I58 KELLY136
A-Folio
15/6/89
MODE H ON

I58 KELLY Y15A
A-Folio
15/10/89
MODE H ON

I was twenty in 1968.

I'd gone to university, having read the *Feminine Mystique* because my father picked it up at an airport. Perhaps I also had some sense of a feminist tradition from my mother. I knew that she and her friends had struggled to get some kind of education. At Oxford, the term feminism was in use, but bracketed off...as a term of abuse.

I have a vague recollection of the women's conference at Ruskin in 1970, but I was preoccupied with the student occupation then, which was becoming quite militant. I remember people from Ruskin coming to support us, but I didn't get involved in a women's group until I left university and went to London.

In 1971, maybe it was January 1972, some of us formed The Women's Lobby. Our reference point was the traditional suffrage movement. We wanted to do something that would have an immediate political impact, so we decided to try to get the Equal Opportunities Legislation out of the doldrums...one of the Labor MPs had presented it four or five times to the House of Commons and it had been laughed out. So we mobilised a whole range of women's support groups...to write letters, to speak at meetings, to give the issue a public identity and keep it from continuing as an in-joke in Parliament. Out of this came the *Women's Report*. We thought that unless we could provide women with regular information on current affairs and how this affected them, then we wouldn't be making much progress. Eventually we got into a kind of workshop production of the *Report*. It covered legal, parliamentary and social issues, as well as the arts. Some of us were interested in the question of culture, so we started a section called "Images." We used this wonderful typeface...where women's bodies were shaped into letters and we made these lovely banner headlines. I was involved in that until 1974.

Then came the Women's Art History Collective. The very first meeting took place around that time, and we met regularly for almost three years. We were aware of the women's workshop of the Artist's Union, but we weren't directly involved in it. We wanted to explore new ways of doing historical research about women artists, so we did projects...like self-portraits...exploring the historical and political implications of looking at ourselves. We read Nochlin, Berger and that kind of thing...finally, after we had been meeting for quite awhile, we decided to try teaching *collectively*. We advertised ourselves and were asked by a number of polytechnics to give presentations. The plan was to make sure that everyone had a chance to speak, that no one dominated, and then, to avoid becoming a collective authority as well, so that the audience could feel involved...but, in fact, the whole project was never resolved. I remember it was really amazing going to art schools...you would present your material and you would see the women in the audience gasp, eyes popping at the possibility of someone daring to come out with this, and then back it up with these astounding statistics. It was a horrendous picture...one that you could see there and then, sitting in front of you...here there were these massed ranks of silent women controlled by these, you know, macho, or at least anxious men at the back.

Our efforts to understand those kinds of stereotypes kept bringing up the question of sexuality and, in our group, there was some interest in psychoanalysis. But I remember my first encounter with the Lacanian lot at The Edinburgh Film Festival in 1976; it absolutely enraged me...made me feel so disabled, so ignorant, sort of castrated by my inability to place myself within that discourse. Yet, it really intrigued me...I wanted to translate our material into this other language. But none of the Collective would follow me down that road...everyone went off to develop her own work and it became defunct as a meeting group.

By then, I was committed to writing the history of our projects and some of the other feminist activities of the seventies, because it seemed to me that there was a process of amnesia in the eighties which was so rapid and widespread that the immense revolution initiated earlier was already disappearing. People felt, or were ideologically pressured to feel, they had to erase it. So, I made myself its immediate archivist...feeling that the documents we had collected had to be made available in a certain form, within some kind of framework, that underlined their significance.

"Each article had to be discussed in detail, then corrected and okayed by the entire group. Most of us had never written anything before. So, one by one, frogs in the throat, knees shaking and all that, we read our contributions. I remember Lorna's. She was hesitant, apologizing first for all the faults we would encounter, and then, finally, after we had coaxed her to continue, she began. The clarity, yes, that's the way it was, we thought. But more, her turn of phrase transported us into a realm of...well, collective ecstasy, I guess, since when she finished no one said a word."

(continued from page 41)

They are interrupted by a man, presumably a friend, in a black silk shirt (presumably washable), but no grey hair (probably dyed). "How old are you?" One Earring asks immediately. The Shirt is taken aback. "Ah...same as you, I guess. What difference does it make?" "No, no, you're younger," she persists. "Never mind," No Lipstick, coming to his rescue, "I think he qualifies. So tell us, what about your students then?" "Mine? ...Well, they're too young to remember or perhaps don't want to... take the concept of repression, Freud's, that is... One of them said to me, 'You mean you want to do something, nobody stops you and you still don't do it? That sucks, sir.'" "Amazing," says No Lipstick. "Tragic," adds One Earring. Then, exchanging The Look of Utter (and Tragic) Amazement, they proceed with their complaints. Meanwhile..

(continued on page 45)

HISTORIA | Detail from section two, 1989.

GRISELDA POLLOCK

I had often thought of dedicating INTERIM *to Dora's mother—the woman who never made Freud's acquaintance. He assumed she had housewife's psychosis: too old for analysis? Too old to be noticed? In a sense, she underlines the dilemma for the older woman in representing her sexuality, her desire, when she is no longer desirable. She can neither look forward, as the young girl does, to being a woman, that is having the fantasized body of maturity; nor can she return to the ideal moment of maturity—ideal in that it allows her to occupy the position of the actively desiring subject without transgressing the socially acceptable definition of the woman as mother. She is looking back at something lost, acknowledging perhaps that "being a woman" was only a brief moment in her life.*

Mary Kelly, "Invisible Bodies: On INTERIM"

SPEAKING AS
DORA'S MOTHER

Dora's mother makes only a slight appearance in Sigmund Freud's case history, "Fragment of an Analysis of a Case of Hysteria ['Dora']": "I never made the mother's acquaintance. From the accounts given me by the girl and her father I was led to imagine her as an uncultivated woman and above all as a foolish one, who concentrated all her interests on domestic affairs. . . . She presented a picture, in fact, of what might be called 'housewife's psychosis.' "[1]

In Mary Kelly's project, INTERIM, Dora's mother has a voice: she becomes a historical presence. For Freud, the older woman was an absence of desirability, hence of significance. To be written into history is to be desired, and history is now being written through women's desire to understand the historical moment of the Women's Movement begun in 1968.

The Women's Movement is undoubtedly one of the major political presences of the late twentieth century. INTERIM focuses on the memories and meanings of " '68" for a generation of feminists produced by that moment. Like the suffrage campaigns before it, the second wave of feminism revised the understanding of "femininity." By naming and contesting the social and economic forces which disempower women, feminists also opened an examination of the psycho-symbolic shaping of human subjects within sexual difference, asking not, "What is Woman?"

39

but, "Is Woman at all?" Such a radical critique of given notions of sexuality and gender raises important questions for those of us, called women, who must live within the nomination, but who struggle politically, personally, and culturally to overwhelm its limits, while recognizing, at the same time, its specific pleasures.

Like Mary Kelly's earlier project, POST-PARTUM DOCUMENT, which generated a signifying space for the mother as the subject of desire, INTERIM disperses into our culture another repressed presence, the sexual woman broaching what is called "middle age," a woman whose desire exceeds our culture's limited imageries of the feminine. INTERIM breaks a taboo by speaking a femininity where it is symbolically negated, but not in order to affirm some other, primordial femininity or radical difference. Here Kelly follows Michèle Montrelay: "The adult woman is one who reconstructs her sexuality in the field that goes beyond sex." By creating imageries and discourses to utter the position of the older woman, INTERIM causes femininity and its sexualities to pass into discourse, and, as importantly, it precipitates their entry into new relations to the woman-as-subject, rather than object, of the look. The silence and iconic passivity encoded as femininity (so strikingly signified by Dora's mother, who is both silenced by, and "pictured" in Freud's text) is disrupted by women's discourse, their pleasure in the signifier, and "their theoretical as well as creative work, especially on sexuality itself."[2] Creative work is thus no second-order discourse, recirculating knowledge formed elsewhere. It is productive of definitions and meanings for the subjects of femininity—that is, those who are subjected to, and who also realize their subjectivity through, the positions of femininity.[3]

In assembling the materials for INTERIM, Kelly logged scores of conversations with women entering a stage in their lives marked negatively by our culture's *figurations of femininity*, or the alignment, typically, of femininity with an image of the woman as the object of man's desire, or the mother. Like a Freudian case study, INTERIM puts its subjects under analysis. By listening to personal and political histories for symptoms, it excavates the psychic investments sedimented in memory and traced across both women's and culture's fantasies about the body, power, history, and money. Like Freud's "dream work," "art work" aims to produce new knowledge by restructuring the relation between the forms of representation and the material struggling for—or against—it. In INTERIM, the point of view of the woman we symbolically call "Dora's mother," combined with a review of the historical period since 1968, produces a new and useful understanding of what structures femininity and its moments, historically and individually, and what might yield other orderings.

What are the strategies of representation adequate for the double articulation of such a historical project—at once, case history and transforming analysis? As a first step, INTERIM specifies the discourses and institutions in relation to which feminine identities are defined and regulated: money, body, power, and the socio-political. It then "plays" over them in its humorous delight at the instability of any subjectivity.

At the same time, it voices the fantasies and desires that make femininity excessive—that is, always exceed its culturally coded definitions—but which are registered in its representations as being both "more than" (excess) and "not quite" (lack). INTERIM, therefore, enunciates femininity as transgressing the norms in order to produce new feminist possibilities. It displaces women's subordination to these figurations by activating a signifying space where voices and presences resonate in multi-layered textualities which press on the very limits of sexual definition—of that which defines "women's place in the processes of reproduction and its representations."[4]

The phrase is Julia Kristeva's. It speaks to the necessity for feminists to grasp hold of the idea of sexual difference as operating both as a *political economy of sex* (or the determinate socio-economic arrangements for the regulation of sexuality and the perpetuation of the species, which enjoin a legalized, appropriative heterosexuality) and, in Freudian terms, an *economy of desire* (that is, the organization of subjectivity around separation, division, and lack, an organization which simultaneously supports identity and threatens to disrupt its always fictitious stabilities).

INTERIM is an intervention in the spaces of representation in the domain of contemporary art. Its significance can only be fully apprehended by recognizing its filiation with three moments in the cultural field, in which it is: a work of the scale and ambition of the grandest history paintings; a work whose formal strategies and signifying possibilities are radicalized in the manner of the high modernist project it recapitulates and supersedes; and, finally, a work which articulates the complexities of subjectivity in historical and social formations, a major theme in the critical culture of which Mary Kelly's work over the last twenty years has been a major initiator and representative.

In the 1970s, the idea of a critical practice, socialist or feminist, being realized in a single, definitive work was canvased and rebutted. Mary Kelly's INTERIM clearly refutes the possibility in its form as a multi-faceted discourse as much on, as within, the practices of art. Its four sections include diverse materials, formats, and connotational registers: silk-screened perspex panels of posed garments and hand-written stories; glitzy galvanized steel greetings cards mounted at eye level, with printed inscriptions and a running gag forming a visual rebus; steel books bearing a designer's layout of text and photographic image; and three-dimensional steel forms quoting United Nations statistics. A viewer is presented with few icons, but many images, no single text, but many textualities. A visually startling and spatially dominating work, INTERIM seduces with quite specific material and aesthetic pleasures.

Yet it demands more than a specular form of consumption. Like painting, it provides striking emblematic images and the invitation to identify with postures, gestures, and states of mind. Like classic cinema, its meanings build up by repetition and stylistic rhymes, by plots and subplots, characters and stories, dialogue and catchphrase, expressive mise-en-scène and dramatic moment. Like

Griselda Pollock

the modern social landscapes of a Godardian film, it gives us snatches of lives, fantasies, and social spaces. Like sculpture, with its glinting surfaces and material presence, it alternates between strict, almost minimalist, formalities and playful, rebus-like asymmetries. Finally, like Brechtian theatre, it both engages us with its witty and entertaining vision of current issues, and offers to transform us into creative partners through its use of identification, analysis, and, most radically, humor. Thus, to comprehend the multiple purposes and layered meanings produced by interaction with the work of Mary Kelly, we have to recognize the many strategies—visual, textual, material, dramatic, formal, metaphoric, and metonymic—in play.

By politically reconceptualizing the rhetorics of both high modernism and postmodernist spectacle, Kelly formulates a distinctively feminist intervention in the spaces of representation. Femininity has, traditionally, been positioned as the antithesis of, and threat to, the rigors and disciplines by which Great Art only can be made. This has entailed the exclusion of women from recognition within the privileged domains of high culture, and femininity's discursive construction as the essence of triviality, decorativeness, sentimentality, easy pleasure, and romance. In a word, kitsch. As Andreas Huyssen has argued, the structural division between avant-garde and kitsch is gendered.[5] Postmodernists have questioned modernism's negative evaluation of its "other" by making "appropriations" of mass cultural forms as the signifying material for high art practices. Mary Kelly, however, does not rely on quotation and recycling. She originates forms to produce objects, which she arranges according to a logic that invokes both modernist traditions and mass cultural forms. She thus creates a new space within which both sides of the great divide—high art and popular culture—meet. It is a revealing confrontation. On one side, the work speaks repressed femininities by evoking reviled cultural forms, such as the woman's magazine, the romance, the fashion world, and the supermarket (which are also represented as critical sites of contemporary femininity, invested with power and pleasure as well as anxiety, and in need of political readings). And on the other, these forms (of/as femininity) are installed in the gallery with an absolute "mastery" of the discourses and formalisms of high modernism. So, Kelly's work suspends the false dichotomy between the masculinized discipline of high art and the pejoratively feminized popular culture at the specific point at which the regime of sexual difference shapes both the discourses of modernism and its, often, harmlessly "revolting" postmodern offspring. Dominating its gallery space as a series of material forms, INTERIM, moreover, refutes empty, postmodernist gesturing at reference: it is all about the production of presence. Its objects support traces of subjectivities which are offered to the visitor for reconstituting. What might have been a modernist space only, displaying discrete objects, is converted into another, far more radical one. The event staged by INTERIM creates a signifying space in which the change wrought through feminism can be perceived, and still more radical change becomes possible to imagine.

42

The phrase "signifying space" is also Kristeva's. In her essay "Women's Time," she too defines feminism as being positioned on a historical threshold, as reviewing the history of the Women's Movement, up to and since 1968, in an effort to imagine a way forward. She writes of three generations in Western feminism, two historically current, and the third, a space in the future beyond the politics of equality or integration, and the culture of separatism. The first of these aims to use political campaigning to introduce women into, what Kristeva calls, linear, historical time. Rejecting political solutions, the second involves a programmatic insistence on the radical specificity of women. Art and literature, it says, are to be used to explore the cyclical rhythms and monumental temporalities of the life cycle of women, in an effort to make a language for "the intrasubjective and corporeal experiences left mute by culture in the past."[6]

Having examined the traps of reverse sexism, in which she sympathetically deciphers the violence which women experience in this culture, Kristeva tells us that she can now imagine a new signifying space, wherein feminism would be able to question the very sacrificial system by which every subject, every identity, every sex is formed. Such new significations will not emerge from the repressed culture of women, or somewhere radically outside the system; they must be made by a specific kind of transgression within the system itself. In Kristevan theory, meaning is the effect of a signifying process. This involves the constant play between unity, which attempts to fix meaning and normalize its performance, and process, which both precedes and exceeds any systematization. At one and the same time, it makes any meaning possible and provides for the possibility of transformation. Signifying practice, such as a new textuality or artwork, "means the acceptance of symbolic law together with the transgression of that law for the purpose of renovating it."[7] Kristeva sees modernism as a challenge to arrangements of power embodied in both social institutions and symbolic forms—the signifying system—a challenge mounted by transgressions in signifying practices, which are the sites of exchange between the system and the subject. What Kristeva did not say was that the heroic revolutions of modernism have been effected in the name of men, who are unable (and unwilling) to dispute seriously the system and its symbolic order.

The Women's Movement, with its interventions in signification, is the historic and necessary realization of the Kristevan conception of modernism.[8] The claim that feminism only can supersede modernism is not made by all in the Women's Movement, nor all feminisms. It is a possibility only now being created—at the intersection of a feminist intervention in the textual, the subjective, and the historical.

Mary Kelly's work has always attended acutely to the mapping of sexual difference within both the registers of the socio-economic and the politico-psychic: "In her field of vision femininity is not seen as a pre-given entity, but as the mapping out of sexual difference within a definite terrain, a moment of discourse, a fragment of history."[9] Her work, moreover, has consistently used the material pro-

Griselda Pollock

vided by what our culture might dismiss as women's gossip. Consciousness raising turned conversation into a political resource. Those of us who were part of consciousness raising groups found the terrain of sexual difference, and found history, marked upon our bodies and minds, and written in the discourses which form us, and press as the limits of our fantasies. INTERIM claims the importance of that feminist procedure while, at the same time, interweaving it with theorizations developed in the exchanges between feminism, marxism, political theory, semiotics and linguistics, psychoanalysis, and film and cultural studies, over the past twenty years.

Since 1968, women have been living in both historical time and monumental time. We have been having children and growing older. These "historical" processes we have experienced with a modified consciousness, or, in psychoanalytical terms, an altered subjectivity which our involvement with the Women's Movement has produced. INTERIM hints at how such a subjectivity can be signified, and, in addition, how the very question might be posed within the symbolic system of culture. It is at the intersection of the historical movement of women and the dialectics of feminist theory that INTERIM creates its signifying space.

WORKING WITH
DORA'S MOTHER

It's not that our identity is to be dissipated into airy indeterminacy, extinction; instead it is to be referred to the more substantial realms of discursive historical formation.

Denise Riley, "Does Sex have a History?"

Feminists have not only questioned the ideological category *woman*, they have begun to doubt the stability of the collectivity *women*. Denise Riley has even

HISTORIA | 1989.

suggested that it is a historical formation, embedded in relations of power. Such arguments—which go so far as to anticipate the disappearance of the category—may seem perplexing in the context of a political movement based on the solidarity of women as women. This paradox is at the heart of contemporary feminist theory. Women, as female people marked by gender and sexuality, will not disappear. It's the notion of women as the negative and "other" of a masculine norm, founded on the privilege of the phallus, that is to be displaced.

Mary Kelly's project over the last twenty years has been an intervention in the debates and theorizations of woman, women, and femininity, which have characterized the Women's Movement since the end of the 1960s. One of her early projects, *Women and Work* (1974-5, with Margaret Harrison and Kay Hunt of the Women's Workshop of the Artist's Union), emerged from British feminists' alliance with the struggle of working women for unionization. She also participated in the making of a film about the unionization of women contract office cleaners, *The Nightcleaners* (Berwick Street Film Collective, 1975). *Women and Work* was an installation which examined the sexual division of labor in a London factory following the passage of the Equal Pay Act. It used many forms of representation and documentation, including film, photography, life stories, official documents, tapes, and statistics. In its conceptualization of the cultural as a site for the interrogation of the socio-economic, the project should be compared with the work of an artist like Hans Haacke. And, unlike an expose which uses already theorized notions of social power, the installation produced unforeseen knowledge.

While it clearly revealed the ways employers were installing an even more rigid division of labor to avoid paying women equally, the texts in the exhibition also unexpectedly showed that work and home meant different things to male and female employees. This difference could be read as evidence of emotional or

Griselda Pollock

45

psychic meanings invested in everyday life which make visible what a psychoanalytical vocabulary would call *desire*. Diaries were displayed which recorded the daily schedules of the men and women. These indicated that while work was a time of activity and meaning for men, it was dead-time for women, who focused instead on itemizing their chores in the home and their time with their children. Kelly began to recognize women's investments in areas typically defined by feminist theory as being confined to the unpaid sector of the capitalist economy. The social division of labor and women's predominance in childcare could be read as sites for the psychically-construed pleasures and re-enacted losses which constitute the subjectivity of motherhood. At the time, feminist theory tended to define motherhood as a sociologically conditioned role, in opposition to the conservative claim that it was an expression of biological femininity. The evidence in *Women and Work* pointed to still another way of understanding what it could mean for women: it might be the complex activation of a woman's desire, and its reconfiguration within a patriarchal symbolic order.

Debates such as these were radically reoriented by the publication, in English, of the ideas of the French feminist group, *Psychoanalyse-Politique*, and its politicized readings of psychoanalysis, which foregrounded the psycho-symbolic axis over the politico-economic.[10] Mary Kelly had also become a mother by this time. In the crucible of a historic change at the personal level and at the level of political theory, and an intellectual change fostered by her own artistic practice, Mary Kelly began POST-PARTUM DOCUMENT (1973-9; 135 units in six parts). A work constructed over six years, documenting the reciprocal relations of a mother and child within the gender division and its symbolic representation in language, the DOCUMENT created a significant intersection for debates in the Women's Movement and theoretically grounded arguments then current in art practice.

Its decisive formal feature was that it was a multi-part installation which arranged objects carrying the actual traces of the social process of childcare—diaper liners, a child's drawings, comforter, gifts, and writing slate—within representational schemas which pictured the dominant analytical frameworks of patriarchal culture: science, medicine, education, and art. Conceived within the frame of conceptual practice, but developing a specific discursive relation between its objects and narratives, the DOCUMENT clearly signified its purpose as art. Here was no anti-modernist polemic, suggesting that women's voices could only be articulated by oppositional cultural forms, circulating in alternative cultural spaces. Kelly's strategies formally signified the polemical presence of feminist discourse in contemporary cultural practice— part of an oppositional cultural formation whose significance depended on the relations it implied, by dialectical negation, with hegemonic high modernism.[11]

The cultural community in which POST-PARTUM DOCUMENT was formally and theoretically generated was an expanded one, and included British independent film-makers, the cultural theorists around *Screen* Magazine, and the photographers

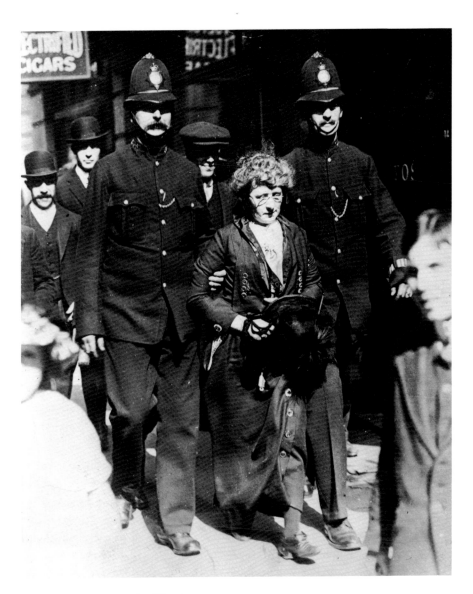

Artist's archival material for *Historia*.
(Arrest of Suffragette, London, 1905)

and theorists, such as Victor Burgin, whose critical interventions were known as Third Area work. The fine artists in this community produced a political critique of The Museum of Modern Art's selective version of modernism, and excavated projects of the twentieth century which articulated the necessary relations between the political and the cultural in ambitiously modernist, but, rarely, purely visual or painterly forms.[12] Important resources for this work were the writings and practices of Brecht, Althusser and Lacan:[13] "The problem, the political problem, for artistic practice in its ideological intervention, could be precisely the transformation of relations of subjectivity in ideology."[14]

POST-PARTUM DOCUMENT was also marked by specific reorientations in the cultural and theoretical debates within the British Women's Movement. When Lacanian theory was first taken up, it often posed women's negative entry into the symbolic order. Feminist readings of psychoanalysis subsequently produced innovative theorizations, in particular with regard to the significance of the maternal body as a repressed, but necessary, support for language and subjectivity.[15] Mary Kelly's DOCUMENT was an attempt to create a reading of femininity through a woman's relation to the maternal body as the site of fantasized plenitude and, also, of symbolically defined loss. A conceptual formal strategy with narrative spaces, relays of signs across materials on which the social relations of the mother-and-child were inscribed and traced, was the means she used to create a signifying space for a maternal discourse. But, by its documentation of the loss of the child as it grew, developed speech, went to school, and learned to write its paternal name, the work could have confirmed woman's negation in the patriarchal system. Instead, Kelly's project concluded with a social reading of the child's accession to language at school, a social institution through which the mother experiences not only the loss of the child to society, but anxieties about inadequate educational provisions. She argued that while the place that the mother occupies as an effect of the signifying chain seems inevitably to make her a failure, or, at best, a victim of circumstance, the position she takes up in representing this place to herself is not one of resignation only. It is not the mother's hopes, aspirations, and ambitions for her child which ultimately are lacking, but the possibility of their realization because of economic constraints, social practices, and the political effects of separation from the means of production, possession, and "advantage."[16]

The journey from *Women and Work*, which attended specifically to the economic moment of production and class, to the maternal body and the psychic instance of femininity, was never a move away from questions of social power and economic relations. As the DOCUMENT showed, power and money impinge on the maternal subject through her personal, historical formation in the social practices of childcare. Shaped by the moment of feminism in which it was produced, the DOCUMENT is a representation of a specific time in women's historical subjectivity. By working through personal, theoretical, and cultural materials in the work, Kelly articulated a space for change where none had been imagined—in the notion of woman biologically defined as mother. In other words, her signifying practice became the site for effecting necessary changes in our knowledge of ourselves, of our psycho-social formations of the "subjectivity in ideology."[17]

This formulation itself betrays a historicity. By the late 1970s, questions of power were being theorized less in terms of ideology than sexuality. The work of Michel Foucault had become important. As with Freud, women played major roles in his histories. In *The History of Sexuality*, Foucault defined sexuality as a historical construct which is an "especially dense transfer point for relations of power."[18] One of the four mechanisms of knowledge and power centering on sexuality Foucault

explored was "the hystericization of women's bodies," and he cites J.M. Charcot and his student, Freud, as contributing, in radically opposed ways, to the figurations of femininity. (Freud made his decisive "discoveries" in his early case studies of hysteria, "Anna O" and, of course, "Dora.")

INTERIM itself is shaped by and reshapes our understanding of this historical conjoin of femininity and its body. *Corpus*, for example, is Mary Kelly's discourse across, from, and through our culture's hystericization of the feminine body. It reworks Charcot's photographic iconography of hysterical postures, in which women's mute bodies were made to expose themselves to his clinical gaze. Further, the regime of power Foucault anatomizes both saturates the feminine body with sexuality, and regulates it in a familial order it is constrained to embody as wife, mother, daughter, and sister. These positions are simultaneously sites for the deployment of power over women, and occasions for resistance. *Pecunia* draws on this schema of power and its conventional pathologies. But, using a Freudian model, Kelly also suggests the force of desire pressing on these positions, which are both places in a regulative system of alliance (a socially defined kin system) producing gender identity, and sites of psychic formations of sexuality (with all the potential disruption to the Law which institutes it that this implies).[19]

Both *Pecunia* and *Corpus* address the sexualization of the feminine body, but they posit a gap between it and its subject. This rupture becomes possible for the woman that these positionalities strategically target as surplus—Dora's mother. Kelly's play of images, stories, and references to the many systems of representation which form subjectivity and sexuality, produces a signifying space for this repressed but powerful subject. INTERIM re-poses Freud's (and Lacan's) famous question, "What do women want?" by representing the desire of the woman he would not notice. Therefore, through its own case histories and fragments of analysis, INTERIM summons a historical presence never theorized by Freud or Foucault—the feminist subject. This subject does not, however, spontaneously know herself. Through INTERIM's layered archeology, bricolage and mise-en-scène, the conditions for the production of knowledge of her historical presence as that subject finally become available. The work's objects and texts function as a screen onto which Mary Kelly projects the traces of the historical, personal, and theoretical processes that turned the feminine subject into an object of feminist analysis, and thus produced the possibility of the feminist subject.

Filmic in its complex uses both of invocatory as well as visual drives, INTERIM produces a new kind of textuality. The presence of words and writing is a taboo in modernist art, though it is a characteristic presence in postmodernist work. Mary Kelly uses a variety of signifying formats strategically to challenge modernism's fetishization of the visual as the site of truth, and to suggest that other registers are equally part of both social and psychic meaning. Her work incorporates knowledge of post-structuralist theorizations of the "text" which critique fixed meaning in favor of an insistence on the precariousness of all meanings, which are held to be but an

effect of a signifying process. "Text" also refers to social relations in which any signifying activity occurs.

Any artwork ambitious to be read as a historical text cannot try to revive the contained and delimited meaning of traditional history painting. It cannot, moreover, be satisfied with the harmless, modernist play of the signifier in its endless evasion of meaningfulness. Rehearsal and quotation from the overloaded sign systems of contemporary mass culture, similarly, are insufficient. Julia Kristeva writes of aesthetic practices as needing to take ethical responsibility for the production of political knowledge. One conceivable site for such an ethico-political supersession of history painting, modernist art, and postmodernist spectacle is the calculated and playful textuality of projects like INTERIM. They summon and redefine all our presences in the signifying spaces they create by their interventions in the historical, the textual, and the subjective. These are initiated as feminist, but inevitably exceed that originating moment to affect all subjects, all identities, all sexes.

NOTES

1. Sigmund Freud, *Case Studies I*, Pelican Freud Library, vol. 8 (London: Penguin Books, 1977), p. 49.

2. Mary Kelly, "Invisible Bodies," *New Formations*, no. 2 (1987): 12.

3. Elizabeth Cowie, "Woman as Sign," *M/F*, no. 1 (1978), argues that signifying practices do not merely reflect or represent definitions of women (which are produced in socio-economic or political practices perceived to be more primary or foundational), but they construct and circulate meanings for the term *woman*, which are never independent of, but equally are not reducible to, definitions produced in other social practices.

4. Julia Kristeva, "Women's Time," *The Kristeva Reader*, Toril Moi ed. (Oxford: Basil Blackwell, 1987), p. 190.

5. Andreas Huyssen, "Mass Culture as Woman: Modernism's Other," in *After The Great Divide* (London: Macmillan, 1986), pp. 44-65.

6. Julia Kristeva, "Women's Time," p. 94. In the global and post-colonial struggle of women, this dialectic around sameness and difference poses even more acute dilemmas. Do the differences between women outweigh the potency of the sexual difference, which inflects any experience of exploitation, be it of race or class, just as much as these social formations themselves inflect any structure of sexuality or gender?

7. Julia Kristeva, "The System and the Speaking Subject," pp. 22-9.

8. It is not femininity that is itself the negative end point of rupture, as Kristeva once argued. It is the politics of the psycho-symbolic, as conceived by certain tendencies in contemporary feminism, which can activate that point.

9. Mary Kelly, "Desiring Images/Imaging Desire," *Wedge*, no. 6 (1984): 7.

10. It was Juliet Mitchell's *Psychoanalysis and Feminism* (London: Allen Lane, 1974) which had such an impact. Her arguments appeared in her earlier *Women's Estate* (London: Penguin Books, 1971). The spread of interest gave rise in 1976 to The Patriarchy Conference, at London University, the same year that a significant debate in the women's press was generated by the exhibition of the first parts of Mary Kelly's POST-PARTUM DOCUMENT at the Institute of Contemporary Art, London. Excerpts are reprinted in Rozsika Parker and Griselda Pollock, *Framing Feminism: Art and the Women's Movement 1970-85* (London: Pandora Press, 1987), section III. 9-11, pp. 203-5.

11. The term *oppositional* functions in relation to Raymond Williams' work. He specifies that, in any cultural formation, there will be dominant, emergent, and residual practices. In addition, the emergent may be merely alternative, that is, waiting its turn to be dominant, or it may be truly oppositional, and articulate meaning excluded and repressed by the combination of interests and powers which form the dominant hegemony. Raymond Williams, *Marxism and Literature* (Oxford: Oxford University Press, 1977).

12. Current arguments about the possibility of reviving history painting, which claim to be overcoming modernism's refusal of social or political reference, seem a little belated in the context of the much more sophisticated and historically grounded set of strategies being articulated by Burgin, Kelly, Mulvey, and Wollen, among others.

13. Griselda Pollock, "Screening the Seventies: Sexuality and Representation in Feminist Practice—a Brechtian Perspective," in *Vision and Difference: Femininity, Feminism and Histories of Art* (London: Routledge, 1988).

14. Stephen Heath, "From Brecht to Film: Theses, Problems," *Screen* 16, no. 4 (1975/76): 39. See also: "Ideology is not to be replaced by some area of pure knowledge; rather from within ideology, art, as realism in the Brechtian sense, attempts to displace those formations of ideology by posing the specific relations of those formations on the mode of production." Stephen Heath, "Lessons from Brecht," *Screen* 15, no. 2 (1974): 108-9.

15. The issues raised by feminism's initial engagement with psychoanalysis in Britain are covered in the collected papers given at The Patriarchy Conference, London University, 1976. See also the debate generated by the exhibition of POST-PARTUM DOCUMENT in 1976 at the ICA, reprinted in Rozsika Parker and Griselda Pollock, *Framing Feminism: Art and the Women's Movement 1970-85* (London: Pandora Press, 1987), section III. 9-11, pp. 203-5.

16. Mary Kelly, *Post-Partum Document* (London: Routledge, 1983), p. 168.

17. See note #15.

18. Michel Foucault, *The History of Sexuality, Volume One: An Introduction*, (London: Allen Lane, 1979), p. 103.

19. For an excellent discussion of this point, see Jacqueline Rose, "Feminism and the Psychic" in *Sexuality in the Field of Vision* (London: Verso Books, 1986).

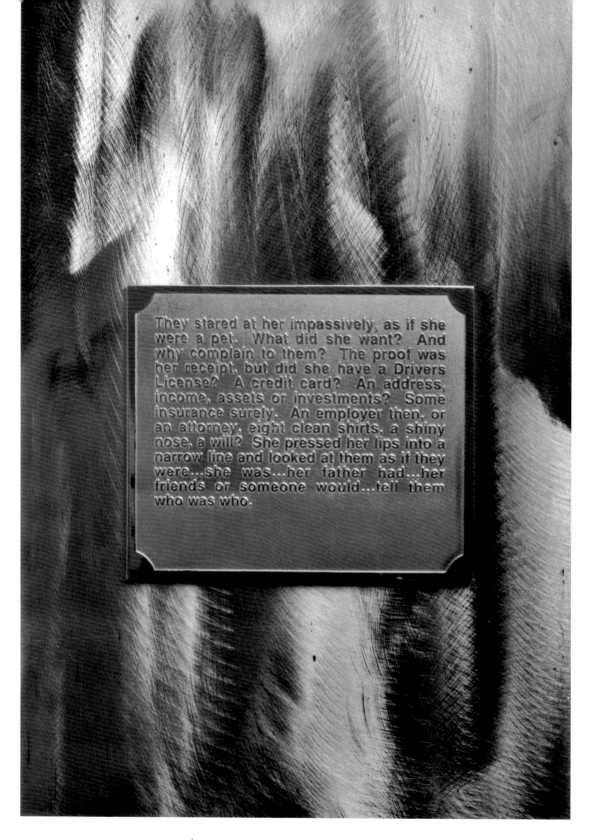

They stared at her impassively, as if she were a pet. What did she want? And why complain to them? The proof was her receipt, but did she have a Drivers License? A credit card? An address, income, assets or investments? Some insurance surely. An employer then, or an attorney, eight clean shirts, a shiny nose, a will? She pressed her lips into a narrow line and looked at them as if they were...she was...her father had...her friends or someone would...tell them who was who.

POTESTAS | Detail of "Bona" section, 1989.

HAL FOSTER | The conceptual structure of INTERIM is delineated in its section titles: *Corpus*, *Pecunia*, *Historia*, and *Potestas*. As well as your inquiry into psychoanalysis, they suggest different discourses (Marxist, Foucauldian . . .), even different disciplines (anthropology, history. . .). Why these four terms, and in this relationship?

MARY KELLY | In the five years before I began the production of INTERIM, I developed an archive of informal conversations with women on the subject of aging, and these were the recurring themes. There is obviously a Foucauldian methodology implied in the notion of archive. That is, I wanted to know how the various themes of this interim moment in a woman's life were constituted as discourses and, more ambitiously, I wanted to look at the formation of these discourses within the historical field of feminism. So, I guess *Corpus* recapitulates the debates of the 1970s, which resulted in a move away from an emphasis on positive images to a psychoanalytically informed concern with spectatorship. Then, *Historia* provides an overview, and reflects a preoccupation of the early 1980s with the question of "agency," or—from a political perspective—the problem of deciphering the relationship between social and psychic moments of oppression. *Pecunia* revives the topic of commodity fetishism—woman-as-consumer, and all that—which originated in the 1960s, but it transforms it into a question of her desire. This reflects my interest in the psychoanalytic concept of fetishism and its implications for women. And *Potestas*, I think, acts again as an overview by placing questions of money, property, or position in a wider context. It parodies a kind of biological, sociological, even psychological, binarism in Western culture—a schema of difference which perpetuates sexual or social division. What I wanted to look at, in particular, was the way power reproduces this division in language—in visual representation. I hope this section takes the debate into the 1990s by reassessing what we have or, as it seems, what we haven't achieved in terms of empowerment.

H F | Visually, INTERIM is a complex work, not only in its play of image and text, but in its repertoire of sign systems. You make references to popular culture,

though not in the guise of catatonic re-presentations of commodity images. Instead, you engage the different discursivities of everyday forms. *Corpus* alludes to fashion images, medical diagrams, romance fiction, and its plexiglass panels have the scale of small billboards; *Pecunia* plays on the language of classified ads, genres of personal fiction, and the kinds of riddles and puns found in greeting cards (these also seem to have suggested the size and display of its galvanized steel units). What other languages of everyday life are figured in INTERIM, especially in *Historia* and *Potestas?*

M K | You've covered *Corpus* and *Pecunia* so, to continue, *Historia* refers to generic newspaper or magazine layouts—galleys, paste-ups . . . the metaphor of "making history." It takes the form of very large stainless steel pages, with images and texts screened on oxide panels. Laura Trippi suggested a reference to Kiefer which was interesting because it is precisely the heroic notion of a nation which I'm contesting here, with this critical history of an oppositional movement. Perhaps it's my version of his *Women of the Revolution*. *Potestas* is an extended pun on the sociological jargon of measurement. Its three-dimensional graph may be comic in its familiarity at one level—actually, at first glance it probably looks like minimal sculpture—but on another, it refers to the graph in a Derridian sense, a visual parallel to the schema of phonemic oppositions, as well as a trope for sexual difference.

H F | In POST-PARTUM DOCUMENT, you visualized and analyzed the mother-child relationship. In INTERIM, you address a particular stage in the lives of women, a stage beyond reproduction, and putatively beyond desire (the given positions of femininity, you suggest), when the aging process comes to the fore. There is, then, a return to the body here, as announced directly in *Corpus*, and, indeed, the posing of the apparel in its image panels refers to the "passionate attitudes" of hysteria defined by J.M. Charcot. Now, in a 1987 text on INTERIM, you implied that the female body was elided in the shift from the visual theater of Charcot to the talking cure of Freud, a shift from looking to listening which marked the beginning of psychoanalysis. Was the female body elided again in the critical focus on the patriarchal unconscious in feminist discourse of the 1970s? In INTERIM, do you relate this moment of elision to the foundational one of psychoanalysis? And, if INTERIM is involved in a return to the body, how are we to think of this?

M K | Firstly, it's primarily within the medical discourse that the visible body was eclipsed, as you say, by new sciences like biophysics. But Freud's own discovery of the unconscious can be included in that process, too. I would say that in our time, the repressed—that is, the body—has returned as spectacle in the form of advertising. This is the new theater where the hysterical posturing of women proliferates. In both POST-PARTUM DOCUMENT and INTERIM, I've problematized

the image of the woman not to promote a new form of iconoclasm, but to make the spectator turn from looking to listening. I wanted to give a voice to the woman, to represent her as the subject of the gaze. And, secondly, INTERIM proposes not one body but many bodies, shaped within a lot of different discourses. It doesn't refer to an anatomical fact or to a perceptual entity, but to the dispersed body of desire. I think of Lacan's description of erotogenic zones as including the phoneme, the gaze, the nothing, and, in this sense, I feel that the installation should be an event where the viewer gathers a kind of corporeal presence from the rhythm or repetition of images, rather than views the work from the fixed vantage point of traditional perspective. Finally, people often say that the body as a visual image is absent in my work. I would argue against such a limited definition of image. The visual field, after all, includes not only the register of iconic signs, but the index and symbol, as well. This heterogeneity of the sign—Norman Bryson calls it the aniconic image— is crucial for me because it can have the effect of displacing the female spectator's "hysterical" identification with the male voyeur. So, writing for me is obviously more than what is said. It's also a means of invoking the texture of speaking, listening, touching—Lacan suggests that the invocatory drives are, in a sense, closer to the unconscious—a way of visualizing, not valorizing, what is assumed to be outside of seeing. This is done in order to distance the spectator from the anxious proximity of her body—ultimately, the mother's body—the body too close to see, which is linked at the level of the unconscious to an archaic organization of drives and which bars the woman's access to sublimated pleasure.

HF | The primary focus of feminist-psychoanalytical film practice and theory in the last decade has been on the question of feminine spectatorship. Theoretically, this has suggested a move away from questions of voyeurism and fetishism, the staples of the patriarchal unconscious, toward questions of hysteria, masochism, and melodrama. Your work has been associated with a related trajectory in art practice and theory. In particular, what is your aim in this archaeological recovery of hysteria? Why is it theoretically important at a time when it is clinically almost nonexistent? Incidentally, the Surrealists were also interested—though obviously in a different way—in hysteria; Breton and Aragon called it "the greatest poetic discovery of the end of the nineteenth century."

MK | Well, it's exactly the continuing romance of hysteria that interests me. Lacan—who was, at one time, very close to the Surrealists—talked about psychoanalysis as the "hystericization of discourse," and poses analysis against mastery, and hysteria against knowledge. And then, there are the women who were expelled, not from Charcot's theater, but from Lacan's *école freudienne*—I'm thinking here of Luce Irigaray. For them, the hysteric exposes the institution's fundamental misogyny; that is, woman founds the theory of psychoanalysis and sustains it by making the exchange of ideas between male theorists possible. So, hysteria,

marginalized in one domain, becomes central in another . . . which is, of course, feminist theory. Just to give you some examples besides Irigaray: someone like Monique Plaza says hysteria is the revolt against patriarchy; Michèle Montrelay calls it the blind spot of psychoanalysis; Jacqueline Rose points to the problem of sexual difference; and *Dora's* film collective claims that the hysteric reveals the analyst's symptom and so becomes, in effect, the basis for a critique of Freud. I don't think INTERIM is an archaeological attempt to recover the hysteric-as-poet or -dissident, but to see her more as a theoretical symptom within contemporary work.

H F | In INTERIM, as in POST-PARTUM DOCUMENT, you point to gaps or soft spots in psychoanalysis—if these are not too problematic as metaphors—and yet you are generally perceived to be devoted to the work of Freud and Lacan. How would you characterize your negotiation of their theories?

M K | Devoted would not be the appropriate term as far as I'm concerned. I have a rather mercenary attitude toward these texts and use their insights—usually into male fantasy—to articulate their "lack" . . . problematic metaphor intended . . . of ability to deal with feminine sexuality. Their work on fetishism is a prime example. Also, I don't rely on Freud and Lacan exclusively. In *Corpus*, the central thesis revolves around Montrelay's work on the feminine body and Millot's paper, "The Feminine Superego." *Pecunia's* logo, "Pecunia Olet," is taken from Ferenczi's work of the same title on the psychoanalysis of money. And Kristeva's influence seems to me evident everywhere.

H F | In different ways and to different degrees in *Corpus* and *Pecunia*, as in the DOCUMENT, the feminine is located in the positions of mother, wife, sister, and daughter. ("Mater," "Conju," "Soror," and "Filia" are, in fact, the section titles of *Pecunia*.) These positions are no more separable in your work than they are in social life, yet you seem to privilege the maternal term. Could you comment on this dominance in relation to your theoretical interests?

M K | Certainly POST-PARTUM DOCUMENT is a work that deals explicitly with the mother-child relationship. In a way, maternal femininity seems almost synonymous with the notion of womanliness. It's what I'd call the "ideal moment," in that the woman, in relation to her child, is constituted as the actively desiring subject, without transgressing the socially accepted definition of her as "mother." But this poses an immediate contradiction. Maternity is not passive and consequently not "feminine." Also, what happens when the child grows up? Is "being a woman" just a brief moment in her life? Clearly, there is a fundamental instability in the category *woman*, which *Corpus* takes up in exchanges between men and women and among women themselves in the narratives. In a way, I suppose they repeat the hysteric's question: Am I a man or am I a woman? Even when

the figure of the mother appears, for example, in "Extase," she is seen to be masquerading; the happy family is really a farce. In *Pecunia*, I've decentered the maternal paradigm quite noticeably with the sections' titles. The emphasis here is on the whole set of social relations implicated in the designations: mother, daughter, sister, wife. I was thinking of the way Foucault describes the family as conveying "the law through the deployment of sexuality" and "the economy of pleasure through the regime of alliance"—or kinship. The stories in *Pecunia* caricature the pathologies he describes as being the outcome of this interchange: nervous woman, frigid wife, precocious child, and perverse adult. The latter is especially important because, in terms of object choice, it cuts across the heterosexual assumption—something I felt wasn't clear enough in *Corpus*. So, in response to the famous or infamous Lacanian question, "What does woman want?" *Pecunia* might be asking its own question: Are there as many forms of identification as there are demands? But the problem for women—and the one that emerges as the crisis when maternal identity is lost or threatened—is the fragility of the primary identification . . . not with the mother, but the father. Kristeva has suggested that it's the remaking of this imaginary father of the preoedipal phase— being able to take his place within language—that's the basis of "sublimational possibility." The last narrative in the "Filia" sequence signifies exactly that failure to identify with the paternal figure in the woman's symptomatic ambivalence about her economic independence.

H F | In *Corpus* and *Pecunia*, there are more references to the signs of class than in POST-PARTUM DOCUMENT (though they are certainly there, too). Is this taken further in *Historia* and *Potestas*?

M K | Yes, I think so. *Historia*, for example, is concerned with social and political, rather than personal, identity. I mean, there are personal accounts of the historical phases of feminism, but the privileged term of enunciation in these narratives is *we*. I wanted to find out how this collective form of address is constituted, how "we" represent "our" histories. This collectivity isn't the seamless entity invoked in slogans like, "Women of the world unite!" The work cuts across this utopian formulation—perhaps a bit too cynically in the slapstick conversations of the "Continued on the Next Page" series—but I think this is a necessary counterpoint to the "reality effect" of the documentary histories and the "nostalgia" of the quotation sequence. One of the consequences of this juxtaposition, which takes the form of a montage of typefaces, is that it problematizes the unity of feminism as an ideology. Even when the point of intersection in the women's stories—there are four, one in each book—is the discourse of psychoanalysis, the meaning of this discourse takes on a specific character depending on the conjuncture in which it emerges for them as a relevant or determining element in their political practice.

H F | Are questions of ethnicity, of whiteness, also addressed? Or are they of secondary importance in the different historical conjunctures which INTERIM works through?

M K | For me, the question of political identity necessarily entails the problem of ethnicity, but that isn't addressed in my work as tokenism; it's taken up around the trajectories of difference—not only sexual difference, but the way white women erase difference in the field of the social or ethnic "other," and, at the same time, vigilantly insist on it when it comes to the other's "other" . . . I mean white men. But let's go back a minute to the interest in collective identity of the early women's movement. It was founded on the notion that "woman" is radically "other"; excluded from language, barred access to pleasure: Lacan summed it up: "She does not exist." So, to come into being . . . to exist, as it were . . . seemed to require a transcendent form of identification: "We are all alike." Within the arena of political organization, the effect was to deny conflict, to disavow hierarchy. One of the quotations in *Historia* describes the ecstasy of a collective writing project. Seized by the discourse of the other—the woman who writes well—they claim it as their own. In another quotation, the "social other," the abject, is projected and then internalized when, in a description of working-class women at a union meeting, someone begins, "They looked indescribably tired, in a way anonymous, perhaps middle-aged or appeared to be even if they weren't." That is, *not* like us. Then, she refers to the music in the background, "the chora," which allows her to transform this feeling into its opposite. The piece ends, "And like us, she loved to dance." There is also a quotation about Vietnamese women which revolves at first around terms like "cold," or "without expression," which signify distance, incomprehension, and difference. It's only when the Vietnamese women talk about their own experience of the war that the white women can identify with their suffering; they're constructed as victims and, I think, for us there is a kind of vicarious over-identification here, which obliterates the political imperative to allow specificity and difference without objectification or hierarchy. Frankly, I don't know how that's done, but perhaps this is a beginning.

H F | INTERIM concerns the desires and fantasies of feminine subjects. How do you regard masculine viewers of your work? How are they positioned by this work? I mentioned to you once that, particularly in front of *Corpus*, I felt like an eavesdropper who was sometimes caught, in a flush of shame—like the voyeur, described by Sartre, who is suddenly seen. You mentioned, in reply, "the fourth look." What did you mean?

M K | Women. I mean the psychic consequence of the historical existence of a women's movement, the word of the "other" internalized in the place of the Law and the father. She sees you seeing.

H F | What do you think about the recent investigations of masculinity? What are the problems of "men in feminism," of "me-too-ism," from your point of view? You mentioned once a problem that fascinates me: the reluctance of women to allow the men they love to give up the phallus. What are the feminist investments in "this other of the other"?

M K | I think it's strategically important to say that men can be, are, and have been, feminists. The critique of masculinity—and by this I don't mean exposes of male fantasies about women, but explorations of the power relations between and among men—is comparable to the issue of ethnicity, that is, the taken-for-grantedness of "whiteness." We can't really progress without the "other" side of both of these coins. Now, as for the second part of your question, I can't really answer it, though perhaps I can clarify—or complicate—it, as the case may be. When I was ruminating over why there was no outcome to the Oedipus complex for the girl, which wasn't ipso facto neurotic, I began to think that perhaps the boy's resolution of this Oedipal drama wasn't so easy, either. I wondered if it would be possible to take Millot's distinctions regarding the masculinity complex for women, and relate them to men. For example, does the woman who fantasizes the possession of the penis parallel the man who acts out its absence in transvestism? Or, is the woman who masquerades as the feminine type—who disguises the lack of a lack, but really makes no demands on her sexual partner—is she comparable to the man who "does what he's got to do"? I mean, what Lacan calls the "male display"; he seems to sense it's a fraud but, in fact, he has no sexual desire for the woman. And, I suppose, you could also take up the woman's desire for the child-as-phallus, and ask what the man's stake is in giving her this "gift"? It seems to me all of this suggests that, for both men and women, demand constructs a rather tentative relation to being or having this phallic term. Of course, no one has it, but I wondered why women seemed resistant to, as you said, letting men relinquish it. It has a parallel in theory, too, because I feel that when we suggest that women have a privileged relation to the mother's body, we are doing more than explaining a different relation to castration, I think we are asserting our difference from men. This assertion seems to point to a certain fear, a fear that's linked, on the one hand, to the desire to be like "them" and, on the other, to the fear of being the same.

H F | I am intrigued by a comment of Lynne Tillman's (and related by Laura Mulvey in your 1986 INTERIM catalogue) that in the narrative of the mother-child relationship in POST-PARTUM DOCUMENT, theory occupies the position of the father in the Oedipal triangle—the "term" that the mother both refers the child to and struggles against. Is there any truth in this for you? If so, has the position of theory changed in INTERIM? How so?

M K | That's interesting. There's a sense in which I did think of POST-PARTUM

DOCUMENT as a kind of secondary revision, in psychoanalytic terms—that is, a rationalization or working through of a difficult experience. You could say this: that theory, like the "third term" of the Oedipal triangle, was the distancing device that made separation from the child possible, but this is simply an analogy. In another sense, though, you could say that psychoanalysis itself became the "third term" in the feminist debate, and provoked a separation from the mother's body—that is, the utopian community of all women—by providing a vantage from which to look at the tentative, constructed nature of femininity and sexuality. The Lacanian diagrams visually represent this "struggle" with theory, which was specific to that historical moment. Now, the terms of the debate have shifted. They're no longer presented as a confrontation between feminism and psychoanalysis, but as a struggle over definitions of feminism and postmodernism. So, the position of theory in INTERIM has changed; it has been assimilated and integrated into an accessible form in the narratives of each section. The question as I saw it when I started this work was how and to what extent had psychoanalysis become another orthodoxy. It now seems evident to me that the political complications of theorizing sexual difference go way beyond this, but I didn't have a position in advance. It's something I worked through, both visually and theoretically, in the making of INTERIM.

H F | How do you see this "struggle over definitions of feminism and postmodernism"? What are its positions, stakes, and strategies?

M K | I'll give you three disparate but, I hope, related examples. *Historia* repeats the image of an unknown suffragette, part cliché, part *memento mori*, and invokes, in place of the hysterics in Charcot's theater, the spectacle of women in the political "theater" of the early 1900s. Dora's mother again . . . but the implications, I think, are not simply that Freud dismissed his patient's "real" mother . . . yet another gap. He certainly knew of the existence of the women's movement—you can tell by the tone of his address to women in his paper on femininity, and there's his association with Bertha Pappenheim, who was herself an activist—yet there is a refusal to contaminate the new science of psychoanalysis with the issue of feminism. Jacqueline Rose has written a provocative piece about a similar reticence on the part of theorists of postmodernism in our time—Jameson or Habermas, for instance—to acknowledge a certain debt to feminism. Psychoanalytic concepts are applied to questions of sexuality and representation as if the discourse was always there. No reference is made to a specific political formation or to the women writers who initially disrupted the complacency of the structuralist paradigm. Perhaps, like Freud, they've never made their "acquaintance." In the art world, especially, even in postmodern practices of resistance, there has been a tendency in some cases to "mediate" the issues into collectible artifacts. Even among women artists, there seems to be an attempt to obliterate, or at least disguise, any trace of feminist commitment. Politics, not sex, has become the pornographic referent in the field of

vision. I'm not saying that art should espouse a particular ideology, but I feel it would be relevant . . . no necessary . . . in the present context, to try to make work that recaptured the historical dimension and the public ambition of the pre-modern era. I mean this in terms of extended audiences, and not just larger work. I always think of Gericault working on *The Raft of the Medusa*, although that might seem like a strange example.

H F | No, it's a good one. We might see it now as official art, another of the great nineteenth-century canvases in the Louvre, but, in fact, *The Raft* was "historical" and "public" precisely because it was contestatory; it was a new kind of history painting which criticized the deadly duplicities of the institutions (political, military, and artistic) of the Restoration regime. The question is, where does one locate analogous critiques today? Granted the restrictive artificiality of terms such as "conceptual" and "feminist" art, one could argue that the contemporary critique of art institutions was initiated by the first and transformed by the second. In what way is a critique of such institutions—specifically the commodity-form of the art object, its exhibition value—articulated in your work, particularly in INTERIM?

M K | I don't believe there can be feminist art, only art informed by different feminisms. The difference lies in how these filter through the work, which is essentially the difference between an appropriation, or colonization, and a "deappropriation," or decolonization, of images of the "other." In my view, decolonization depends on a specific contextualization of the discursive space that surrounds these *objets d'autres*. For example, INTERIM is not simply concerned with imaging the problem of feminine sexuality, but with the historicization of the debates that formed that question in the first place. For me, this approach seems to demand, almost intrinsically, a rupture in the paradigm of single, rather seamless, artifacts. Since the early 1970s, I've worked almost exclusively in the format of extended projects. Each work is divided into sections (INTERIM has four, POST-PARTUM DOCUMENT, six) and develops over a number of years. Each section in INTERIM engages with a particular institutional discourse: fiction, fashion, and medicine in *Corpus*; the family in *Pecunia*; the media in *Historia*; and social science in *Potestas*. These all interact in specific ways within the institutions of art, the museum especially, which are fundamentally split between the demands of education, on the one hand, and those of entertainment, on the other. So, it seems to me that the way to critique the commodity status of the art object may not necessarily be to reproduce it in, what's assumed to be, the critical space of the installation—perhaps this is what's wrong with "the Levine effect"—but to question the very assumption of a spectator who is "supposed to know," meaning also, supposed to buy. I don't think the diversity of positionalities, of spectatorship, can be addressed by a neo-self-referential art of simulation.

H F | Since its beginnings in Vasari, art history has been discursively bound up with biography. Your work complicates the notion of biography, of the artist-as-subject, radically. Moreover, your projects—with their conversations, notes, graphs, and the like—involve extensive forays into the social, and you have mentioned to me the model of the artist-as-ethnographer. What are the ramifications of this model in general, and in your practice?

M K | I suppose in a way my method of working resembles fieldwork—the participant observer keeping notes, writing up the results—but I was thinking more of the "new ethnography" when I said that. It's characterized by two things: an emphasis on the constraints of institutional power, and an interest in forms of experimental writing. This writing, James Clifford says, acknowledges that "identity is conjunctural not essential." So, if I am the indigenous ethnographer of a particular group of women, observing, as it were, the "rituals" of maternity or aging, I'm also, as Clifford points out, "caught between cultures, inauthentic." In the DOCUMENT, as well as in INTERIM, it's the insistent polyvocality in the writing and in the use of media that somehow expresses this. I can think of other artists who use what I would call an ethnographic strategy—Broodthaers, Baumgarten . . . maybe Rollins, Rosler, or Kolbowski—but I am thinking mainly of someone like Hans Haacke. His projects involve extensive research and deploy diverse visual materials in often brilliant institutional critiques. But I've always been troubled by the univocity, by the assumed authority of an artistic or ethnographic presence outside the text. Here I'm not advocating autobiography, but a kind of dialogistic, textual production, in which the historical inscription of the subject describes more than sexual positioning, it questions a particular relation of power. The significance of this attitude, or "model," as you call it, for me is that it leads to work that solicits a certain degree of active engagement in the critique of subjectivity. As for the ramifications in general, well, they're endless.

LIST OF WORK
INTERIM

PART I | **CORPUS** *1984–85*
5 sections: Menacé, Appel, Supplication, Erotisme, Extase
30 panels total, 36 × 48″ each
Laminated photo positive, silkscreen, and acrylic on plexiglass

PART II | **PECUNIA** *1989*
4 sections: Mater, Filia, Soror, Conju
20 units total, 16 × 6½ × 11½″ each
Silkscreen on galvanized steel
Collection Vancouver Art Gallery

PART III | **HISTORIA** *1989*
4 sections
4 units total, 61 × 36 × 29″ each
Silkscreen, oxidized steel, and stainless steel on wood base

PART IV | **POTESTAS** *1989*
3 sections: Populus, Laboris, Bona
14 units total, 100 × 114 × 2″ overall dimension
Etching, brass, and mild steel

MARY KELLY

Born in Minnesota, 1941
Lives and works in New York City

1989

Postmasters Gallery, New York.

C.E.P.A., Buffalo.

Todd Madigan Gallery, California State University, Bakersfield.

1988

McNeil Gallery, Philadelphia.

LACE, Los Angeles.

Galerie Powerhouse, Montreal.

1986

A Space, Toronto.

1985

The Fruitmarket Gallery, Edinburgh. Traveled to Riverside Studios, London; and Kettle's Yard, Cambridge University. Catalogue, essay by Laura Mulvey.

1982

George Paton Gallery, Melbourne.

University Art Museum, Brisbane.

1981

Anna Leonowens Gallery, Halifax.

1979

University Gallery, Leeds.

New 57 Gallery, Edinburgh.

1977

Museum of Modern Art, Oxford. Catalogue by Mary Kelly.

1976

Institute of Contemporary Art, London.

1988

Modes of Address: Language in Art Since 1960, Whitney Museum of American Art Downtown, New York. Brochure, essay by Ingrid Periz.

Mixed Meaning, Barbara and Steven Grossman Gallery, School of the Museum of Fine Arts, Boston.

1987

Conceptual Clothing, Ikon Gallery, Birmingham. Traveled to Harris Museum and Art Gallery, Preston; Peterborough City Museum and Art Gallery; Aberdeen Art Gallery; Spacex Gallery, Exeter; and Camden Arts Centre, London.

State of the Art, Institute of Contemporary Art, London. Traveled to Laing Art Gallery, Newcastle.

The British Edge, Institute of Contemporary Art, Boston. Catalogue, essays by Elizabeth Sussman, David Joselit, Gillian Levine, and Julie Levinson.

Propositions: Work from the Permanent Collection, Art Gallery of Ontario, Toronto.

Aspects of Voyeurism, Whitney Museum of American Art at Philip Morris, New York. Brochure, essays by Andrea Inselmann et al.

Postmasters Gallery, New York.

1986

The Fairy Tale: Politics, Desire, and Everyday Life, Artists Space, New York. Brochure, essays by Frederic Jameson et al.

Identity/Desire: Representing the Body, Collins Gallery, University of Strathclyde, Glasgow. Traveled to Crawford Centre for the Arts, St. Andrews; and McLaurin Art Gallery, Ayr. Catalogue, essay by Nigel Walsh.

1985

Difference: On Representation and Sexuality, The New Museum of Contemporary Art, New York. Traveled to the Renaissance Society, Chicago; List Visual Art Center, Massachusetts Institute of Technology, Cambridge; and Institute of Contemporary Art, London. Catalogue, essays by Craig Owens, Jacqueline Rose, Lisa Tickner, Jane Weinstock, and Peter Wollen.

1984

The Critical Eye/I, Yale Center for British Art, New Haven. Catalogue, essay by John Paoletti and contribution by Mary Kelly.

1983

The Revolutionary Power of Woman's Laughter, Protetch-McNeil, New York. Traveled to Art Culture Resource Center, Toronto;

and Washington College Art Gallery, Maryland.

1982

Vision in Disbelief: 4th Biennale of Sydney, Art Gallery of New South Wales, Sydney.

Sense and Sensibility, Midland Group Gallery, Nottingham. Catalogue, contribution by Mary Kelly.

1981

Typisch Frau, Bonner Kunstverein and Gallery Magers, Bonn.

9th Cracow Meetings, Biuro Wystaw Artystycznuch, Cracow.

1980

Issue: Social Strategies by Women Artists, Institute of Contemporary Art, London. Catalogue, essay by Lucy Lippard.

1979

Un certain art anglais, ARC, Musee d'Art Moderne de la Ville de Paris. Catalogue, essay by Mark Nash.

Europa '79, Heztler, Muller, and Schurr, Stuttgart.

Feministische Kunste Internationaal, Haags Gemeentemuseum, The Hague. Traveled to de Oosterpoort, Groningen; Noodbrabants Museum, en Bosch; de Vleeshal, Middleburgh; Le Vest, Alkmaar; de Beyerd, Breda; and Nijmeegs Museums, Nijmegen. Catalogue, essay by Din Pieters.

Art, Politics, and Ideology, Dartington College of Art, Totnes.

1978

Art for Society, Whitechapel Art Gallery, London and Ulster Museum, Belfast.

Hayward Annual '78, The Hayward Gallery, London. Catalogue, essay by Sarah Kent.

1975

Sexuality and Socialisation, Northern Arts Gallery, Newcastle.

Women and Work: A Document on the Division of Labour in Industry, South London Art Gallery, London.

SELECTED PUBLICATIONS BY THE ARTIST

1990

"Re-Presenting the Body." In *Psychoanalysis and Cultural Theory: Thresholds*, edited by James Donald. London: Macmillan, 1990.

1989

"From Corpus." In *Taking Our Time*, edited by Frieda Forman. Oxford: Pergamon Press, 1989, pp. 153–9.

1987

"Beyond the Purloined Image." In *Framing Feminism: Art and the Women's Movement 1979–1985*, edited by Rozsika Parker and Griselda Pollock. London: Pandora Press, 1987, pp. 249–53. (reprint)

"On Sexual Politics and Art." In *Framing Feminism*, pp. 303–12. See above. (reprint)

"On Difference, Sexuality and Sameness." *Screen* (London) 28, no. 1 (Winter 1987): 102–7.

"Invisible Bodies: On Interim." *New Formations* (London), no. 2, (Summer 1987): 7–19.

1986

"Interim." *The Guardian* (London), June 2, 9, 16, 23, 30, 1986.

1984

"Desiring Images/Imaging Desire." *Wedge* (New York), no. 6 (Winter 1984): 4–9.

"Re-Viewing Modernist Criticism." In *Art After Modernism: Rethinking Reprentation*, edited by Brian Wallis. New York and Boston: The New Museum of Contemporary Art and David R. Godine Publisher, Inc., 1984, pp. 87–103. (reprint)

1983

Post-Partum Document. London: Routledge & Kegan Paul, 1983.

1981

"Feminist Art: Assessing the 70's and Raising Issues for the 80's." *Studio International* (London) 195, no. 991/2 (1981): 40–1.

1979

"On Femininity." *Control Magazine* (London), no. 11 (November 1979): 14–5.

1978

"The State of British Art." *Studio International* (London) 194, no. 989/2 (1978): 82, 109.

1977

"Notes on Reading the Post-Partum Document." *Control Magazine* (London), no. 10 (November 1977): 10–3.

"What is Feminist Art?" In *Towards Another Picture*, edited by Brighton and Morris. Nottingham: Midland Group, 1978.

SELECTED PUBLICATIONS ON THE ARTIST
BOOKS, ARTICLES, AND INTERVIEWS

1989

Elizabeth Hess. "The Good Mother." *The Village Voice* (New York) 34, no. 24 (June 13, 1989): 92.

Jennifer Fisher. "Interview with Mary Kelly." *Parachute* (Montreal), no. 55 (July–September 1989): 32–5.

Laura Mulvey. "Impending Time." In *Visual and Other Pleasures*. Bloomington: University of Indiana Press, 1989.

Mira Schor. "From Liberty to Lack." *Heresies* (New York) 6, no. 4, issue 24 (1989): 15–21.

1988

Griselda Pollock. *Vision and Difference: Femininity, Feminism and the Histories of Art*. London: Routledge, 1988 , pp. 86–7, 167–71, 187–98.

Margaret Iversen. "Fashioning Feminine Identity." *Art International* (London), no. 2 (Spring 1988): 52–7.

Elenore Welles. "Exhibitions." *Artweek* (Los Angeles) 19, no. 25, (July 9, 1988):5.

Paula Marincola. "Mary Kelly." *Artforum* (New York) 26, no. 10 (Summer 1988): 142–3.

1987

Mary Anne Staniszewski. "Conceptual Art." *Flash Art* (London), no. 143 (November–December 1987): 88–96.

Simon Watney. "Mary Kelly." *Artscribe* (London), no. 62 (March–April 1987): 71–2.

Andrea Rehberg. "The Deconstructing Difference Issue of Screen." *Independent Media* (London), no. 65 (May 1987).

Sandy Nairne. *State of the Art*. London: Chatto and Windus, 1987, pp. 119–122, 148–56, 162–3, 166, 200.

Norman Bryson and Elizabeth Cowie. "Invisible Bodies." *New Formations* (London), no. 2 (Summer 1987): 20–8, 29–36.

Paul Smith. "Terminal Culture? The British Edge." *Art in America* (New York) 75, no. 9 (September 1987): 37–41.

1986

Hal Foster. "The Future of an Illusion (or the Contemporary Artist as Cargo Cultist)." In *Endgame: Reference and Simulation in Recent Painting and Sculpture*. Boston: Institute of Contemporary Art, 1986, pp. 91–105.

Monika Gagnon. "Texta Scientiae: Mary Kelly's Corpus." *C* (Toronto), no. 10 (Summer 1986): 24–33.

Andrea Fraser. "On the Post-Partum Document." *Afterimage* (Rochester) 13, no. 8 (March 1986): 6–8.

"Mary Kelly and Laura Mulvey in Conversation." *Afterimage* (Rochester) 13, no. 8 (March 1986): 6–8.

Margaret Iversen. "Difference: On Representation and Sexuality." *M/F* (London), no. 11&12 (1986): 78–99.

Griselda Pollock. "What's the Difference? Feminism, Representation, and Sexuality." *Aspects* (Bath), no. 32 (1986): 2–5.

1985

Mark Lewis. "Concerning the Question of the Post-Cultural." *C* (Toronto), no. 8 (Winter 1985): 56–63.

Diane Neumaier. "Post-Partum Document." *Exposure* (Albuquerque), (Winter 1985).

John Paoletti. "Mary Kelly's Interim." *Arts Magazine* (New York) 60, no. 2 (October 1985): 88–91.

Griselda Pollock. "History and the Position of the Contemporary Woman Artist." *Aspects* (Bath), no. 28 (1985).

Paul Smith. "Difference in America." *Art in America* (New York) 73, no. 4 (April 1985): 190–9.

Jo Anna Isaak. "Women: The Ruin of Representation." *Afterimage* (Rochester) 12, no. 9 (April 1985): 6–8.

Jo Anna Isaak. "Mapping the Imaginary." *Psych Critique* (New Jersey) 1, no. 3 (1985).

Jane Weinstock. "A Post-Partum Document." *Camera Obscura* (Los Angeles), no. 13&14 (Spring/Summer 1985): 159–61.

1984

Craig Owens. "The Discourse of the Others: Feminists and Postmodernism." In *The Anti-Aesthetic*, edited by Hal Foster. Seattle: Bay Press, 1984, pp. 57–88.

Sheena Gourlay. "The Discourse of the Mother." *Fuse* (Toronto) 8, no. 2 (Summer 1984): 68–72.

Caroline Osbourne. "The Post-Partum Document." *Feminist Review* (London), no. 18 (Winter 1984): 136–8.

Lucy Lippard. *Get the Message*. New York: E.P. Dutton, 1984, pp. 141–4.

1983

Freda Freiberg. "The Post-Partum Document: Maternal Archeology." *Lip* (Melbourne), no. 7 (1983): 60–2.

Lip Collective. "Dialogue." *Lip* (Melbourne), no. 7 (1983).

Kate Linker. "Representation and Sexuality." *Parachute* (Montreal), no. 32 (September–November 1983): 12–23.

Jean Fisher. "London Review." *Artforum* (New York) 22, no. 4 (December 1983): 87–8.

1982

Jo Anna Isaak. "Our Mother Tongue." *Vanguard* (Toronto) 11, no. 3 (April 1982): 14–7.

Paul Smith. "Mother as Site of Her Proceedings: Mary Kelly's Post-Partum Document." *Parachute* (Montreal), no. 26 (Spring 1982): 29–30.

1981

Elizabeth Cowie. "Introduction to the Post-Partum Document." *M/F* (London), no. 5&6 (1981): 116–23.

Margaret Iversen. "The Bride Stripped Bare by Her Own Desire" *Discourse* (Berkeley), no. 4 (1981): 75–85.

Rozsika Parker and Griselda Pollock. *Old Mistresses: Women, Art, and Ideology*. London: Routledge and Kegan Paul, 1981, pp. 93–7, 161–8.

Helen Grace. "From the Margins: A Feminist Essay on Women Artists." *Lip* (Melbourne), no. 2 (1981).

1980

Richard Cork. "Collaboration Without Compromise." *Studio International* (London) 195, no. 990/1 (1980): 4–19.

Judith Barry and Sandy Flitterman. "Textual Strategies: The Politics of Art Making." *Screen* (London) 21, no. 2 (Summer 1980): 35–48.

Alexis Hunter. "Feminist Perceptions." *Artscribe* (London), no. 25 (October 1980): 25–9.

1978

Terance Maloon. "Mary Kelly." *Artscribe* (London), no. 13 (August 1978): 16–9.

Mark Nash. "Mary Kelly at the Museum of Modern Art, Oxford" *Artscribe* (London), no. 10 (January 1978): 53–4.

1977

Jane Kelly. "Mary Kelly." *Studio International* 193, no. 987/3 (1977): 186–8.

BOARD OF TRUSTEES

GAIL BERKUS

RICHARD EKSTRACT

MILTON FINE

EILEEN FINLETTER

ARTHUR GOLDBERG *Treasurer*

ALLEN GOLDRING

PAUL C. HARPER, JR.

SHARON KING HOGE

WILLIAM BRIGHT JONES

MARTIN KANTOR

NANETTE L. LAITMAN

ROBERT LEHRMAN

VERA LIST *Vice President*

HENRY LUCE III *President*

PENNY McCALL

JAMES McCLENNEN

RAYMOND J. McGUIRE

THOMAS L. PULLING

PATRICK SAVIN

PAUL SCHNELL

CAROL SCHWARTZ

HERMAN SCHWARTZMAN, ESQ.

LAURA SKOLER

MARCIA TUCKER

STAFF

KIMBALL AUGUSTUS
Security

RICHARD BARR
Volunteer Coordinator

VIRGINIA BOWEN
Preparator/Assistant to the Registrar

JEANNE BREITBART
Art Quest Coordinator/Curatorial Assistant

SUSAN CAHAN
Curator of Education

HELEN CARR
Limited Editions Coordinator

LYNN CRANDALL
Trips Coordinator

ELISA DECKER
Membership

LUIS DE JESUS
Curatorial Intern

ANTONETTE DEVITO
Director of Planning and Development

SARAH EDWARDS
Membership and Contributions Coordinator

RUSSELL FERGUSON
Librarian/Special Projects Editor

ANGELIKA FESTA
Assistant to the Librarian

PHYLLIS GILBERT
Docent/Museum Tour Coordinator

JANET GILLESPIE
Bookkeeper

STEVE HENRY
Public Affairs Assistant

MAREN HENSLER
Collectors' Programs

ELLEN HOLTZMAN
Managing Director

ELON JOSEPH
Security

JUDY KIM
Grants Coordinator

PATRICIA KIRSHNER
Operations Manager

ZOYA KOCUR
High School Educator

SOWON KWON
Library/Special Projects

ALICE MELENDEZ
Receptionist

CLARE MICUDA
Assistant to the Director

FRANCE MORIN
Senior Curator

BARBARA NIBLOCK
Administrator

SARA PALMER
Director of Public Affairs

DEBRA PRIESTLY
Registrar

HOWARD ROBINSON
Security/Operations Assistant

WAYNE ROTTMAN
Gallery/AV Coordinator

ALEYA SAAD
Special Events Coordinator

GARY SANGSTER
Curator

MARGARET SEILER
Publications Coordinator

ABIGAIL SMITH
Assistant to the Administrator

SUSAN STEIN
Admissions/Bookstore Coordinator

NEVILLE THOMPSON
Assistant to the Operations Manager

LAURA TRIPPI
Curator

MARCIA TUCKER
Director

MARGARET WEISSBACH
Coordinator of Academic Programs

ALICE YANG
Curatorial Coordinator

LISA ZYWICKI
Curatorial Administrative Assistant

67